May 2013

Ray,
Hopefully this can be a good guide when you come to visit
♡ KRV

SOUTH INDIA
Pinnacle of Cultural Heritage

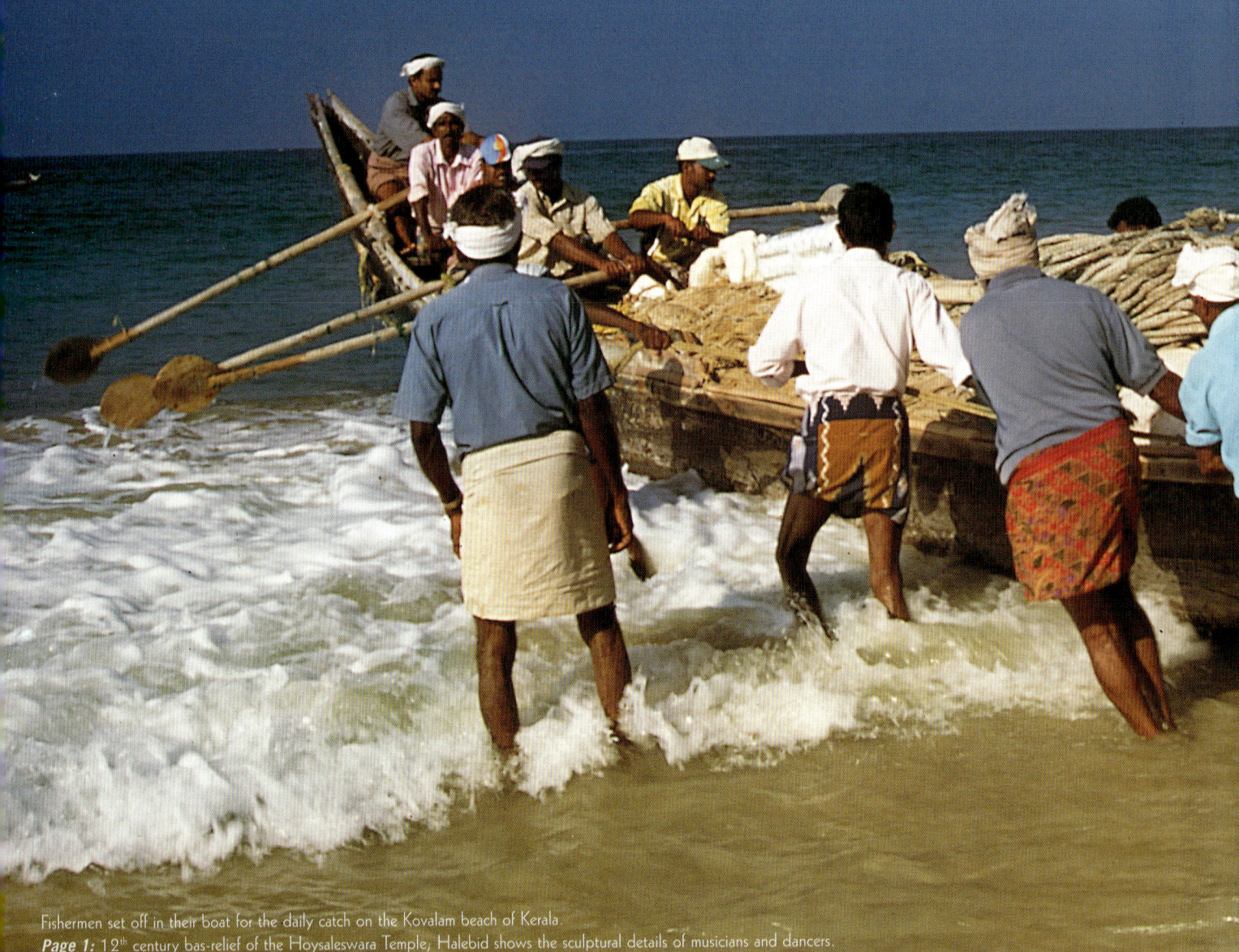

Fishermen set off in their boat for the daily catch on the Kovalam beach of Kerala.
Page 1: 12th century bas-relief of the Hoysaleswara Temple, Halebid shows the sculptural details of musicians and dancers.

Published in 2009 by
Prakash Books India Pvt. Ltd.
1, Ansari Road, Daryaganj, New Delhi-110 002, India
Tel.: 2324 7062-65, Fax: 2324 6975
E-mail: sales@prakashbooks.com
Website: www.prakashbooks.com

Copyright © 2009 Prakash Books India Pvt. Ltd.
Copyright © 2009 Text and Photographs Tarun Chopra

All rights reserved. No part of this publication may be reproduced, stored in a retrieval system or transmitted in any form or by any means, electronic, mechanical, photocopying, recording or otherwise without the written permission of the publisher.
ISBN : 978 81 7234 312 5

Printed & bound by EIH Press, Plot No. 22, Sec.-5, IMT Manesar, Gurgaon, India

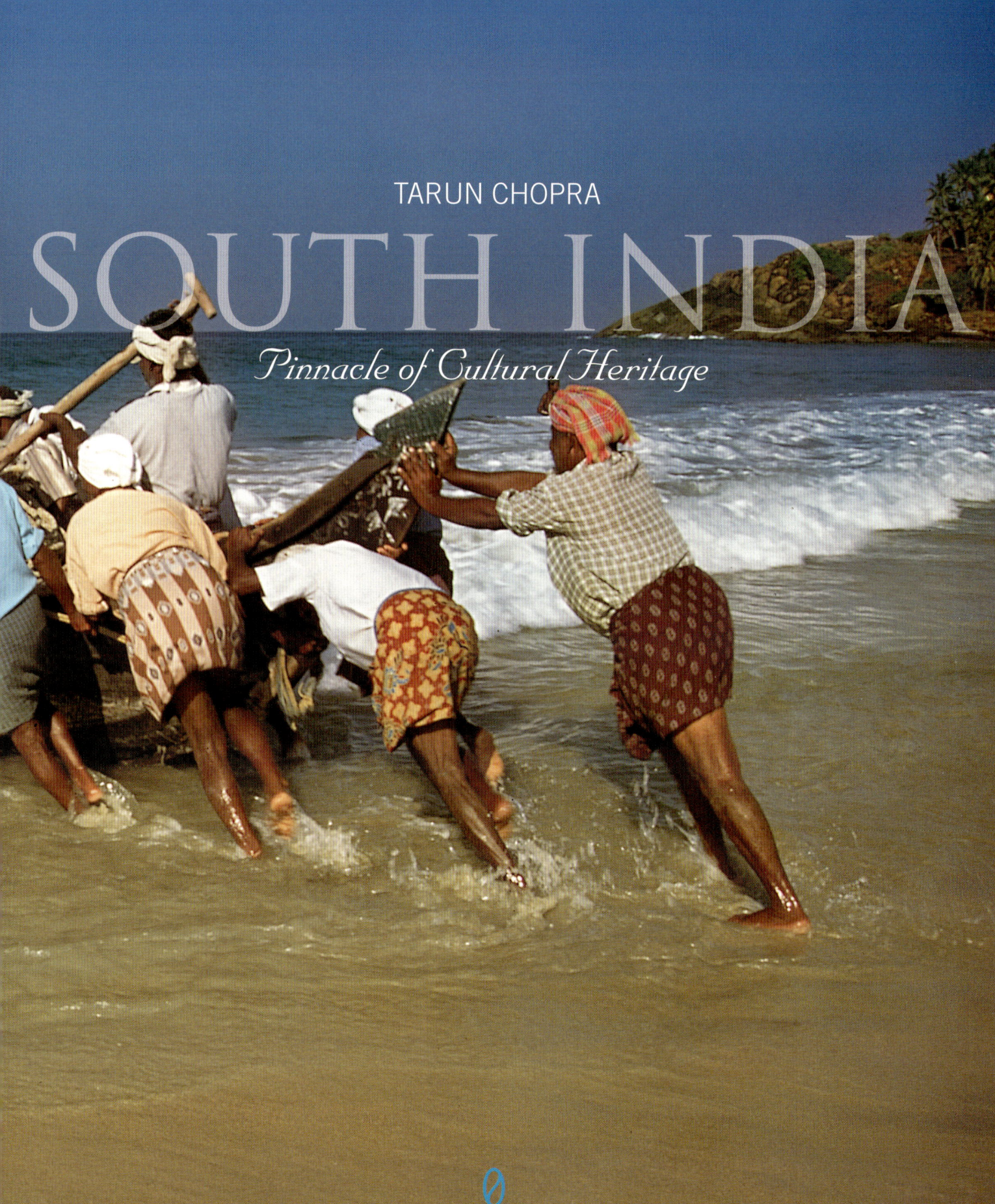

TARUN CHOPRA

SOUTH INDIA

Pinnacle of Cultural Heritage

PRAKASH BOOKS

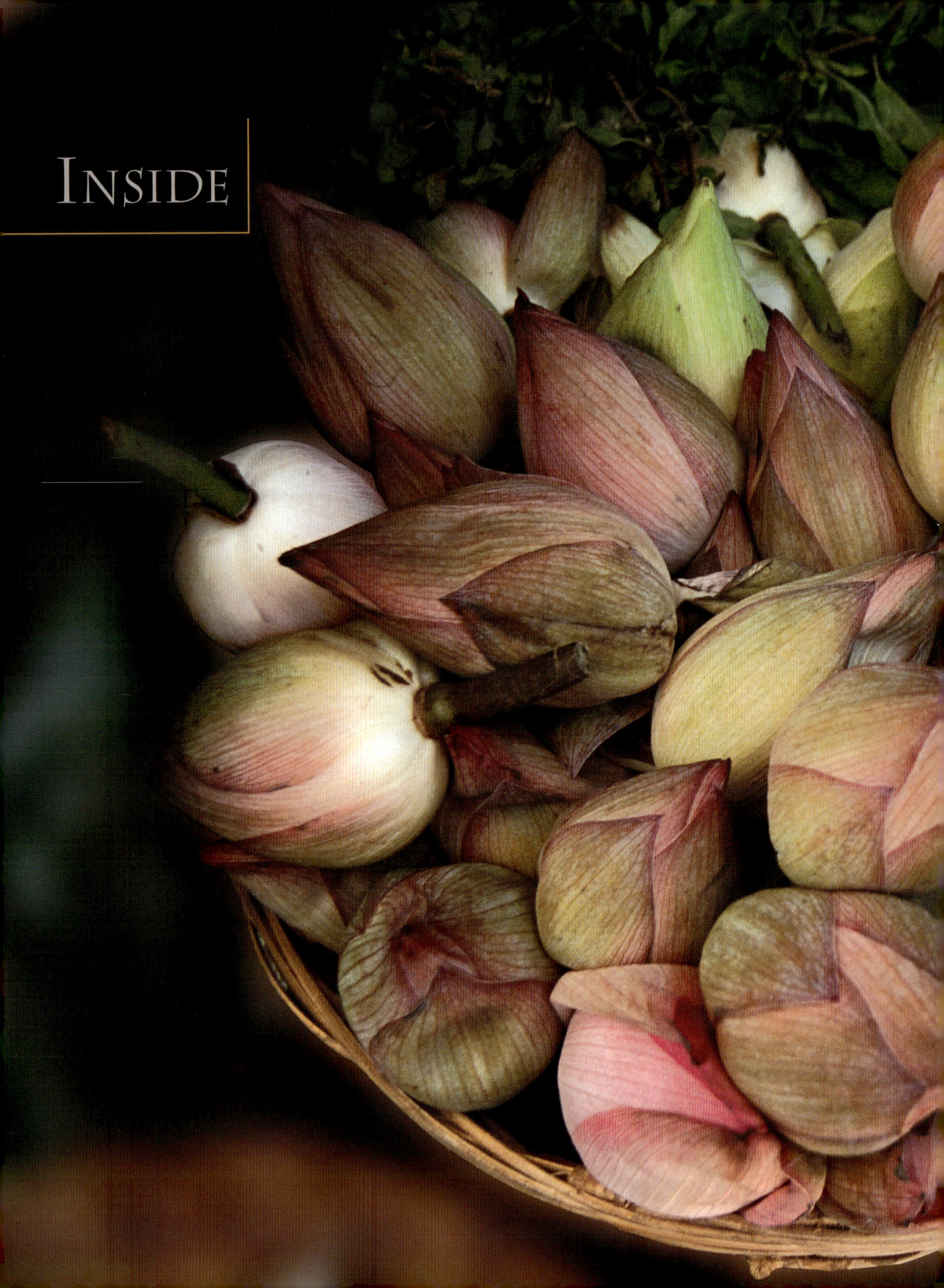

INSIDE

Chennai 9

Kanchipuram 21

Mahabalipuram 29

Pondicherry 37

Chidambaram 45

Gangaikonda-
cholapuram 51

Darasuram 57

Tanjore 63

Trichy 73

Chettinad 81

Madurai 85

Kerala 97

Bangalore 125

Mysore 131

Somnathpur,
Halebid & Belur 141

Shravanabelagola 159

Badami, Aihole
& Pattadakal 161

Hampi 177

Hyderabad 187

Goa 195

Aurangabad,
Ajanta & Ellora 207

Mumbai 221

South India, bounded by the Indian Ocean in the South, the Bay of Bengal in the East and the Arabian Sea in the West, is largely comprised of the four Dravidian states of Kerala, Karnataka, Andhra Pradesh and Tamilnadu (in India, language has been the criterion for the division of states). Though they are treated as a unit for convenience, and share certain basic similarities in outlook to the undiscerning visitor, they have distinct cultural and linguistic traditions. What we know as South India does not necessarily conform to the location of the Tropic of Cancer, which runs through India and splits the country into two equal halves.

While the general conception about the southern states is of their lofty temple gopurams and generic food such as dosa, idli and sambhar, there is actually a wealth of culture, cuisine and sights to be enjoyed in this fascinating peninsula.

Since North India bore most of the brunt of the invaders throughout history, South India was relatively sheltered from these attacks; hence, Hinduism is conserved here in its purest form. South Indian temples adhere to the strict discipline of thousand year old traditions.

Islam is predominant mostly in Hyderabad in Andhra Pradesh, where the Mughals had tried briefly to make inroads into the Deccan, and in some parts of coastal Kerala, the southernmost state, which used to be thriving centres of commerce for seafaring Arab traders in the fifteenth and sixteenth centuries. Kerala also had a strong Christian influence and was a base for missionary work. Hence, some of the oldest traditions of Christianity are found among the Syrian Christians. Saint Thomas, the apostle is considered to be buried in Chennai. No wonder, the

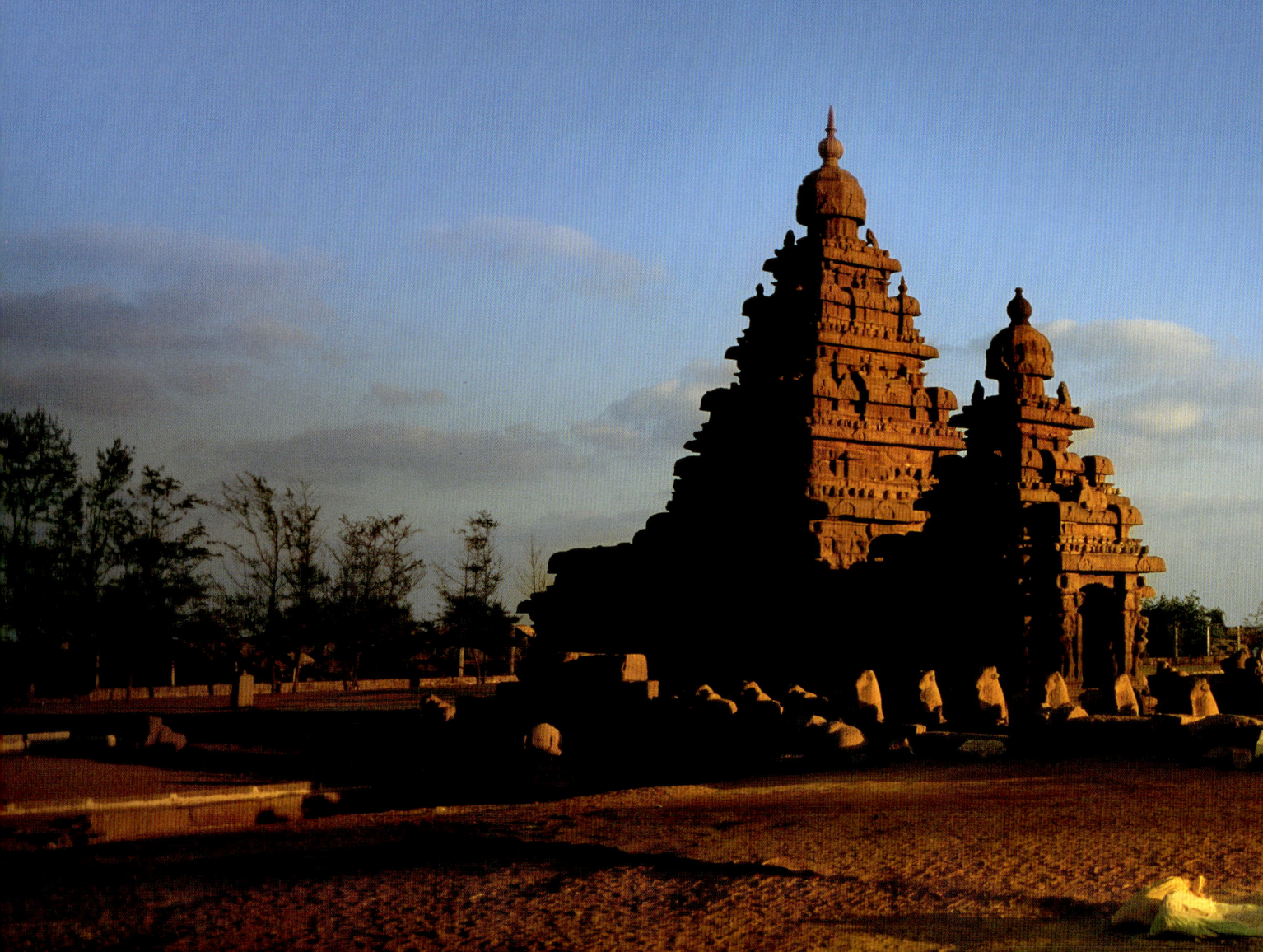

largest concentration of Christians in India is to be found here.

South India is known for its temples around which entire townships have sprung up. Unlike in the North, a temple in the South has not confined itself to being merely a place of worship but is responsible for setting moral standards and establishing village assemblies, tribunals, banks, granaries, hospitals and schools around it, thereby serving as the custodian of society. This reflects in the conservative mores of the people, and probably explains why the temples are often in the very heart of the city.

The Dravidian influence in temple architecture and art has been strong in the South due to the relatively small role played by the Aryans. Each temple complex is a walled enclosure (parikarma) of concentric walls and corridors that houses markets, workshops, educational centres and living quarters. Every temple has towers (gopurams) that face the four cardinal points of the compass and serve as landmarks for travellers. Features that are associated with the temple itself include the water tank and kitchen to prepare food for the divinities, and a temple chariot that is drawn through the streets on festival days with the temple deity mounted on it. The complete devotion and understanding of rites and rituals that you see in the South is not seen anywhere else in India.

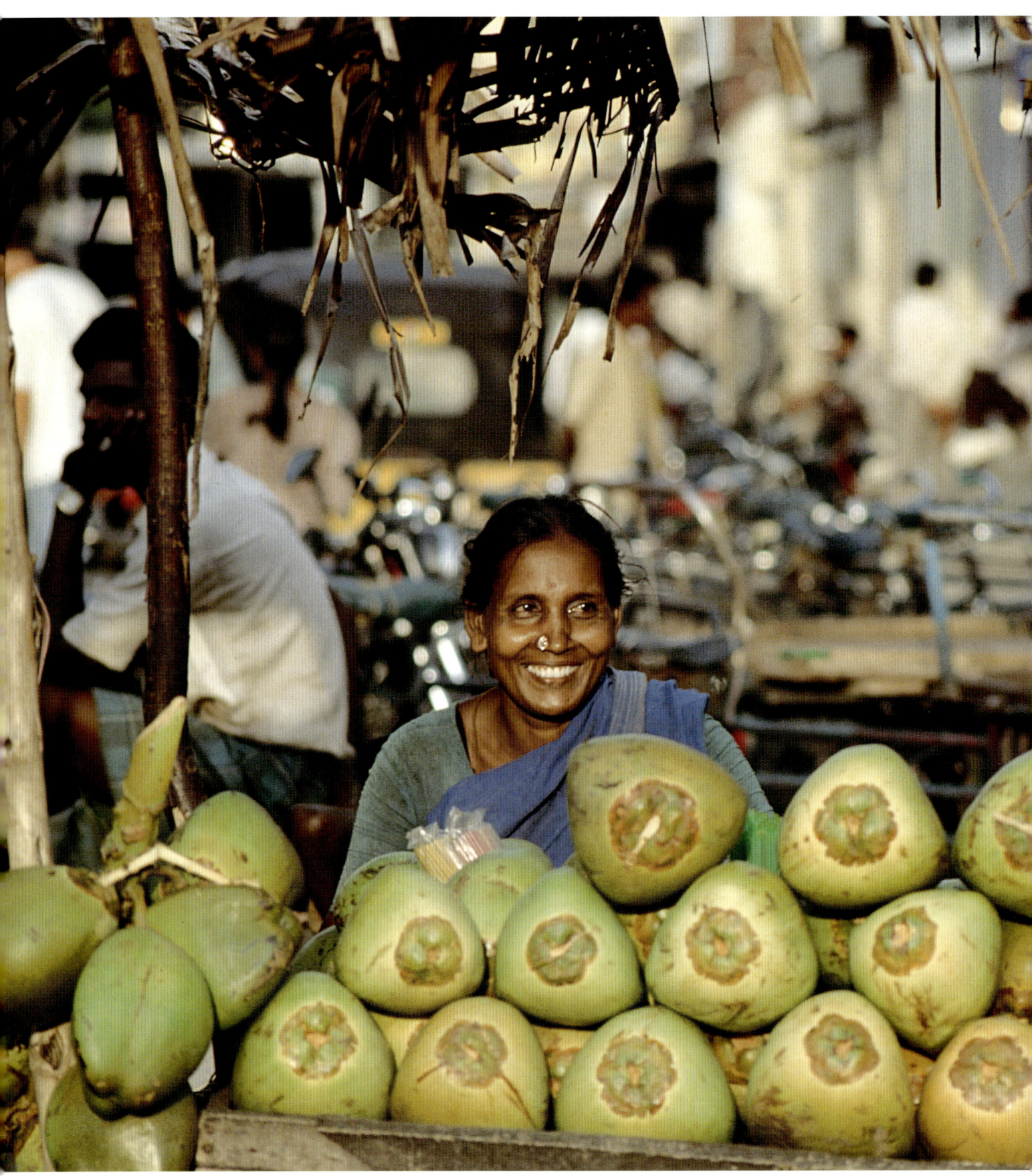

CHENNAI

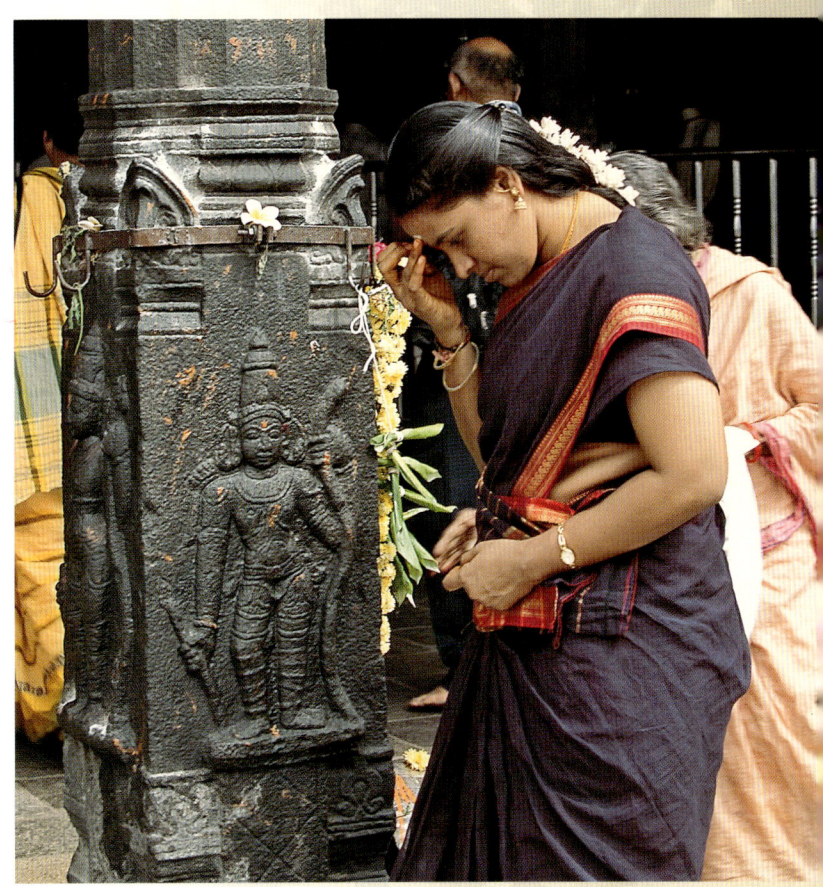

Madras, now called Chennai, is the capital of the South Indian state of Tamil Nadu. Like the rest of the metro cities of India, its name has also been changed under the new wave of local nationalism or politics. It is the home of the Tamil speaking population and is the cradle of Tamil literature. Classical Indian dance, the Bharatnatyam and the Dravidian temple architecture are important contributions to the country's classical history.

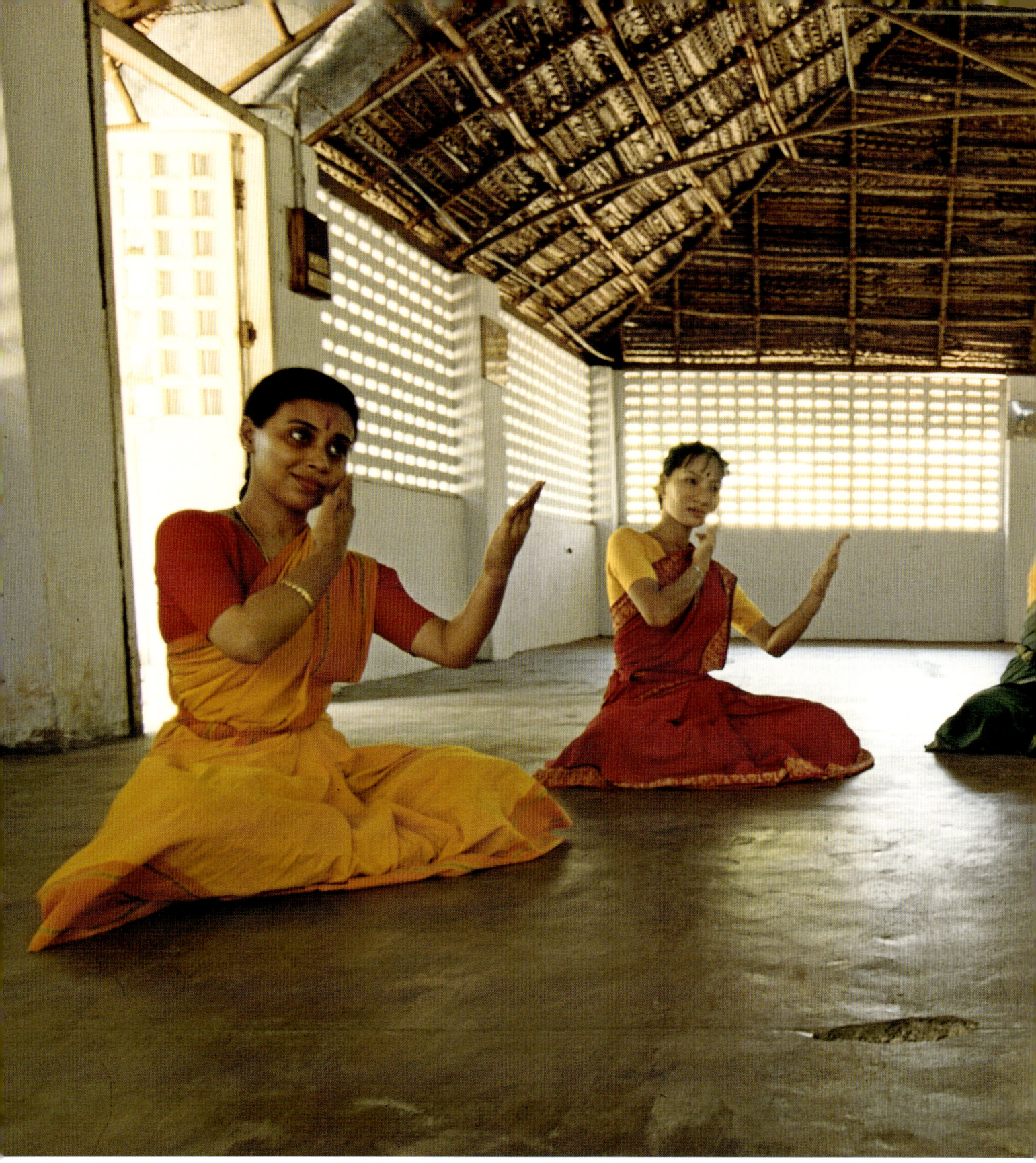

Kalakshetra, founded by Rukmani Devi Arundale, is a unique classical dance and music university that is responsible for reviving these ancient arts. Students come from world over to learn these performing arts in its serene traditional ambience. ***Page 4–5:** A basket full of lotus flowers, which in Hinduism symbolizes spiritual liberation, is widely used as an offering to the Hindu deities. **Page 6–7:** View of the Shore Temple in Mahabalipuram at dusk.*

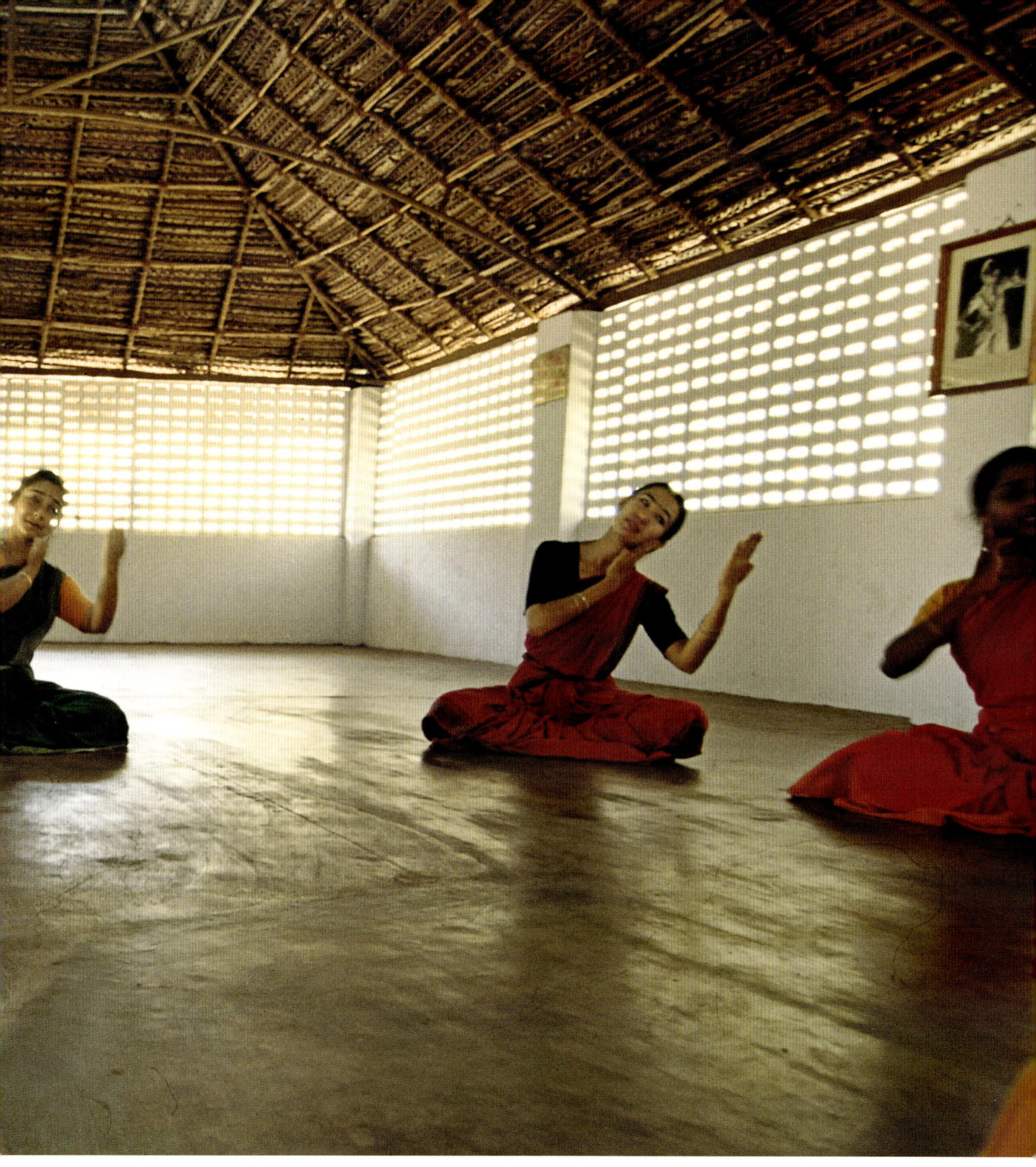

Page 8: A coconut seller with a warm smile waits for the clients to quench their thirst with this natural drink that is available in abundance in South India. **Page 9:** A devotee worships the engraving of a deity in the column of the Kapaleshwara Temple in Chennai.

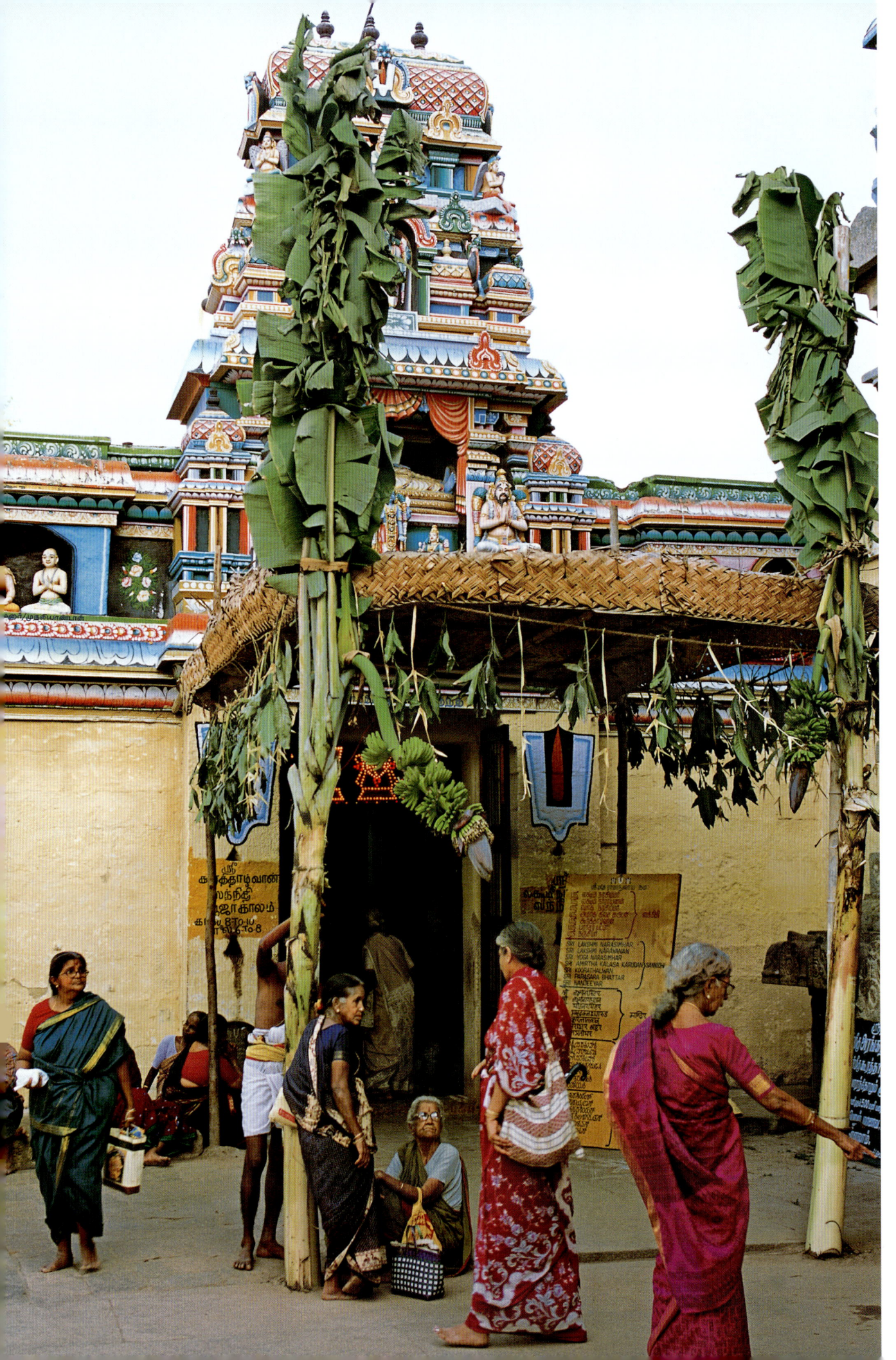

Chennai is an odd mixture of cultures where the influences of the British East India Company coexist with traditional Tamil culture. Therefore, it is not uncommon to find huge old colonial bungalows and churchyards jostling with temples, gigantic cinemas and political hoardings for space and attention.

The major change in the region came when the European traders started to outdo each other to source the material for the spice trade. Initially, it was a race between the Portuguese and the Dutch. The French and the British bought the spices from these traders. Eventually, greed overtook the Portuguese and the Dutch and they raised the prices. This forced the British and later the French to start their own trading companies. Initially, the Europeans were fighting with each other for their trading rights. As the competition grew fierce, they started to dabble in local politics to assure their future. The Coromandel Coast saw numerous battles between the English and the French. Finally, it was the British who emerged supreme. The Dutch were given the trading post of Tranquebar while the French held on to Pondicherry.

Fort St. George in Madras was the governing seat of the English. It was here that an unassuming clerk, Robert Clive, sowed the seeds of the British Empire in India. With his financial and military genius, he was soon able to control Bengal in the east and from there spread company's supremacy over the Gangetic plains of North India. Eugene Yale, founder of Yale University lived in Fort St. George and made his initial fortune as the Governor of Madras. His wedding took place at St. Mary's church in the Fort's compound. Very close to the Fort St. George is the Icehouse. It is in this building where ice was stored, imported by ship all the way from the East Coast of America. Ice, incidentally, was the first commodity to be imported from America.

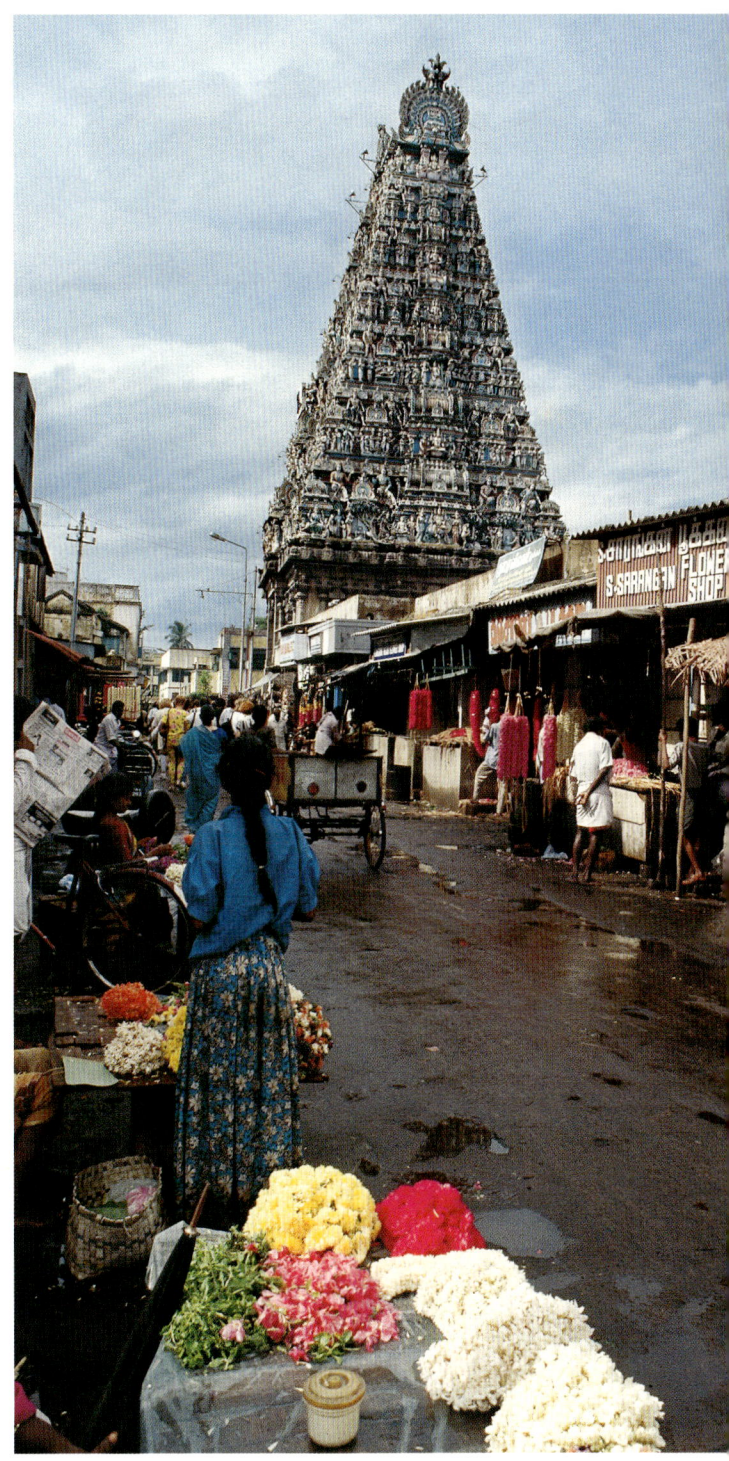

Streets leading to the Kapaleshwara Temple in Chennai are full of shops selling religious paraphernalia and fresh flowers that devotees use as offerings to the temple deities. **Opposite page:** At the time of the temple festivals, banana trees are used as a part of the decoration as they represent abundance.

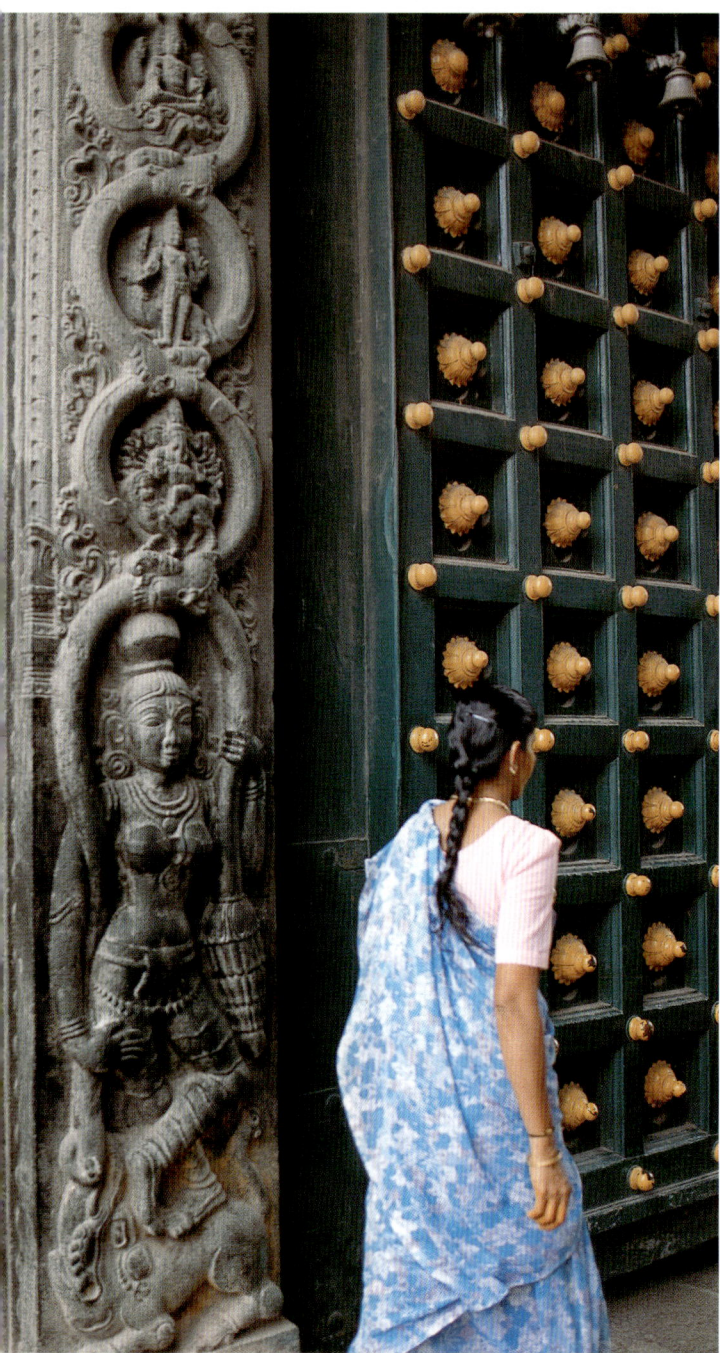

Today, this fourth largest city of India is outgrowing itself at a rapid pace. It is a busy metropolis with a thriving industry for example textiles, leather, Infotech and movies to name a few. Lately there has been a boom in automobile industry, with Koreans and Japanese finding the highly educated workforce in the port city as an attractive investment environment.

The tourist attractions of the city are few. The Hindu temple of Kapaleshwara in Mylapore dates back to the thirteenth century. It is dedicated to Lord Shiva. Legend has it that when Shiva was talking to his wife Parvati, he found her engrossed watching a peacock. This angered him and he transformed her into a peacock. Parvati in the form of a peacock did a number of penances to please her lord. Finally, Shiva relented and changed her back to her beautiful self. The place is called Mylapore (peacock place) to mark their reconciliation. It has a vast tank on the west where the devotees bathe on religious festivals. On the eastern entrance is a towering thirty-seven meter high, multicolour gopuram (gateway). It is crowded with statues of gods, goddesses and saints from the Puranic legends. There is a shrine depicting Parvati in the form of a peacock, worshipping Shivalingam. On the whole, it is an excellent introduction to the temple life, sculpture and architecture of the South. This is amplified in great proportions in the other temple towns of Southern India.

Not far away from the temple of Mylapore is San Thome cathedral. It is here that the mortal remains of Doubting Thomas, apostle of Jesus Christ, are said to be buried. The Hindu influence in Christian art is evident with Christ standing on a lotus flower with peacocks on either side. And the statue of Mary is draped in a sari.

The temple entrances are as impressive as the temples that lie within; huge teak doors are held in place by gigantic monolithic granite pillars; carvings on the pillars represent the guardians of the temple. **Opposite page:** The Kapaleshwara Temple in Chennai has a shrine dedicated to childless couples. Those desiring an offspring hang wooden cradles on the trunk of the wish granting tree in the temple compound.

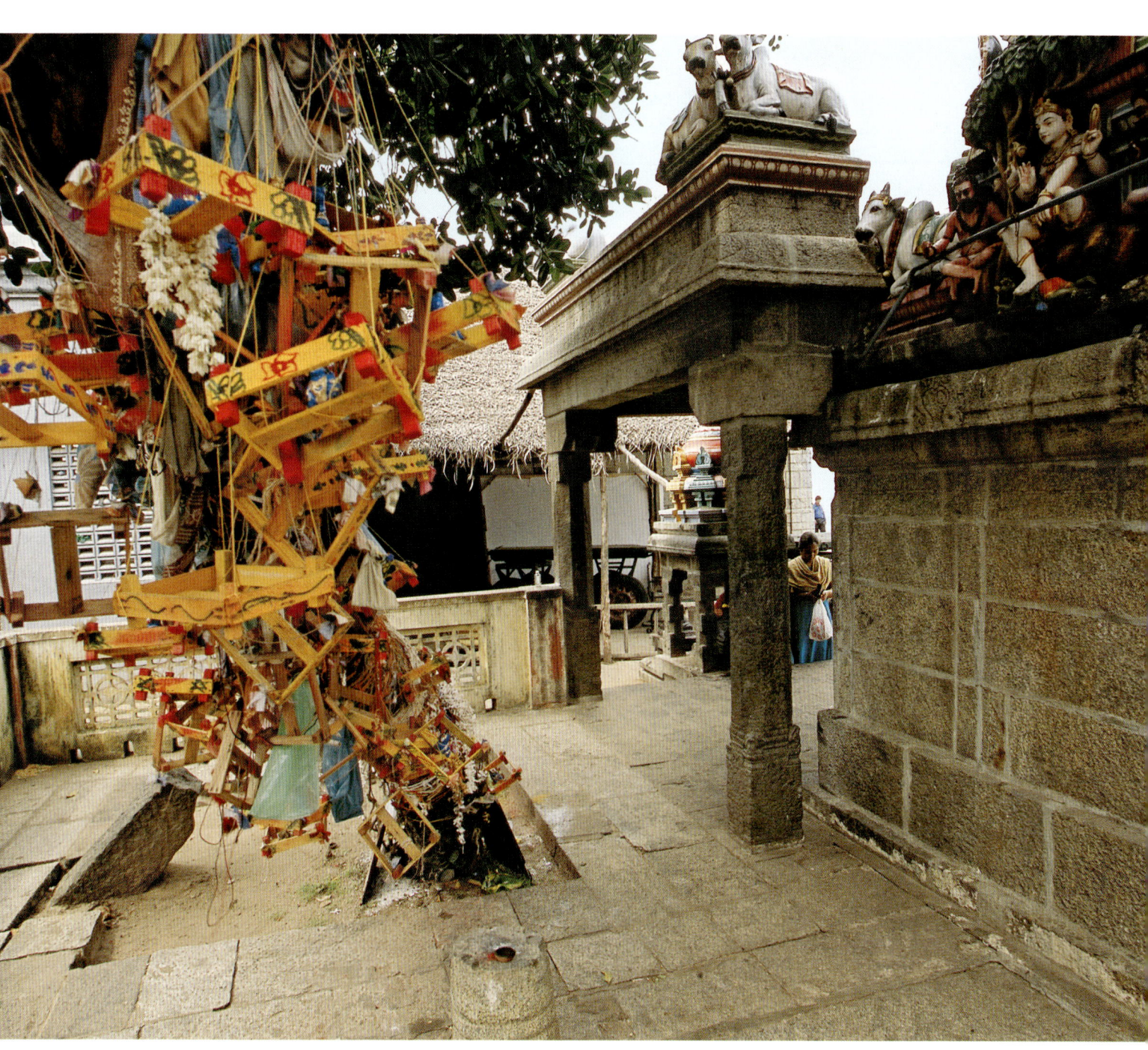

The government museum is housed next to a beautiful, red sandstone colonial theatre and has a fabulous collection of Chola bronzes; there is a fantastic display of the Nataraja, Shiva as a cosmic dancer, with explanations of the various gestures of the Lord. Another interesting place to visit in this city is Kalakshetra, the temple of art. Rukmani Devi Arundale, renowned Bharatnatyam dancer of her time, founded this unique classical Indian dance and music university in 1936. She revived the classical dance form of Bharatnatyam and gave it respectability.

A university set in a natural environment; it is dedicated to teach established art forms in traditional style. The morning prayer meeting of the students under the banyan tree is an enriching experience. The sights, which overshadow the monuments in Chennai, are the temple town of Kanchipuram and the Shore Temples of Mahabalipuram.

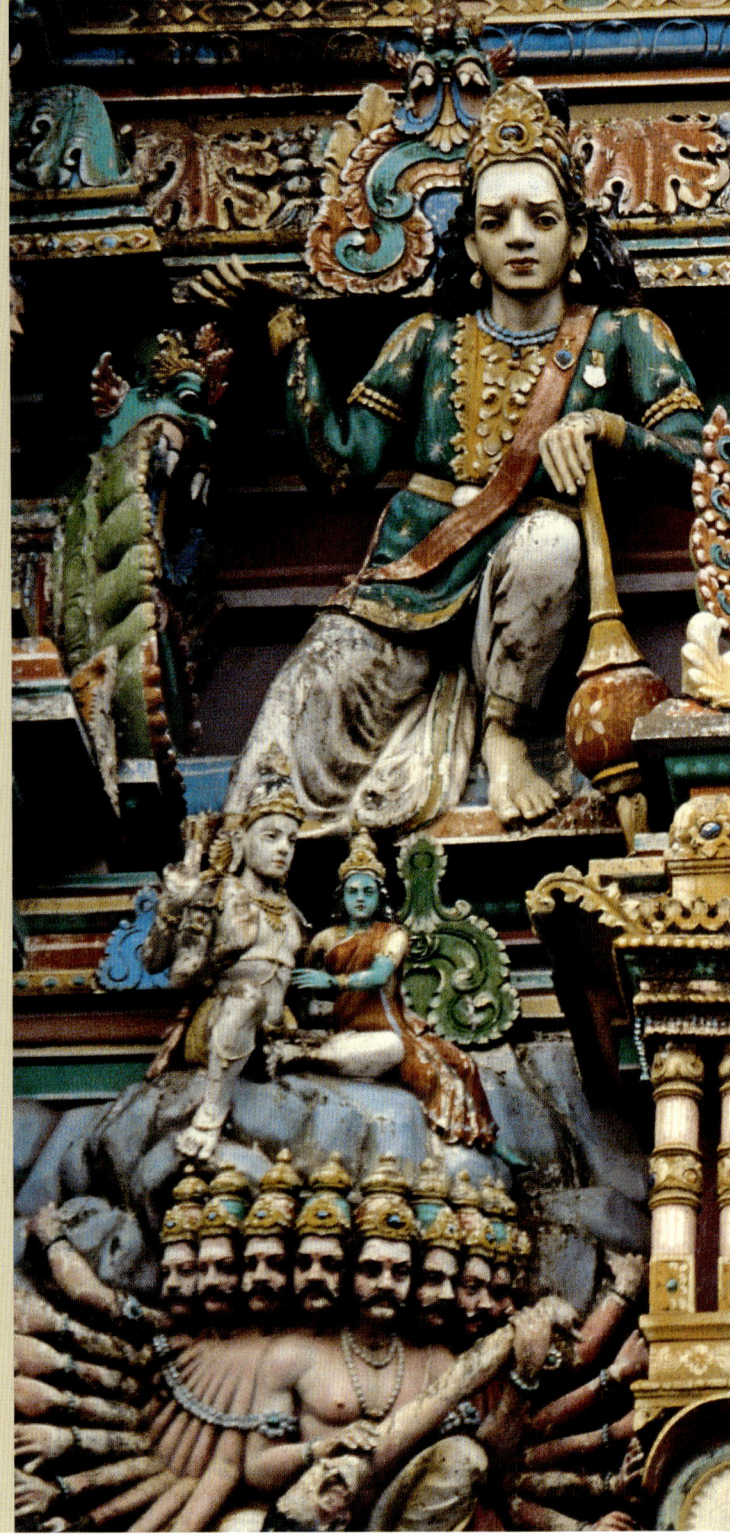

Vast array of colours are used in the decoration of auspicious floral designs at the entrance of South Indian homes. *Opposite page:* The temple towers or the gopurams are decorated by multitude of sculptors narrating stories from the Hindu mythology.

SOUTH INDIA

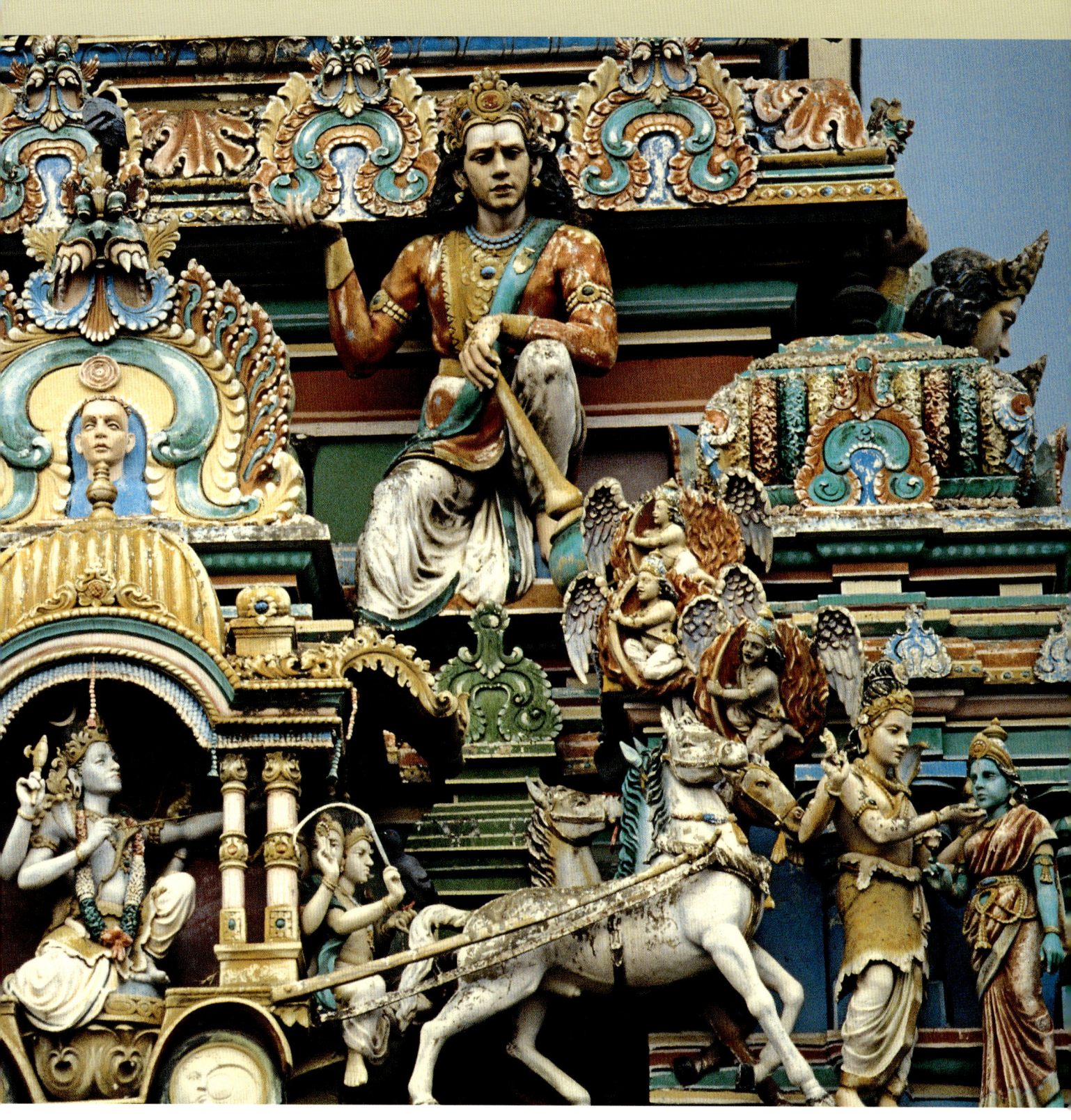

SOUTH INDIA

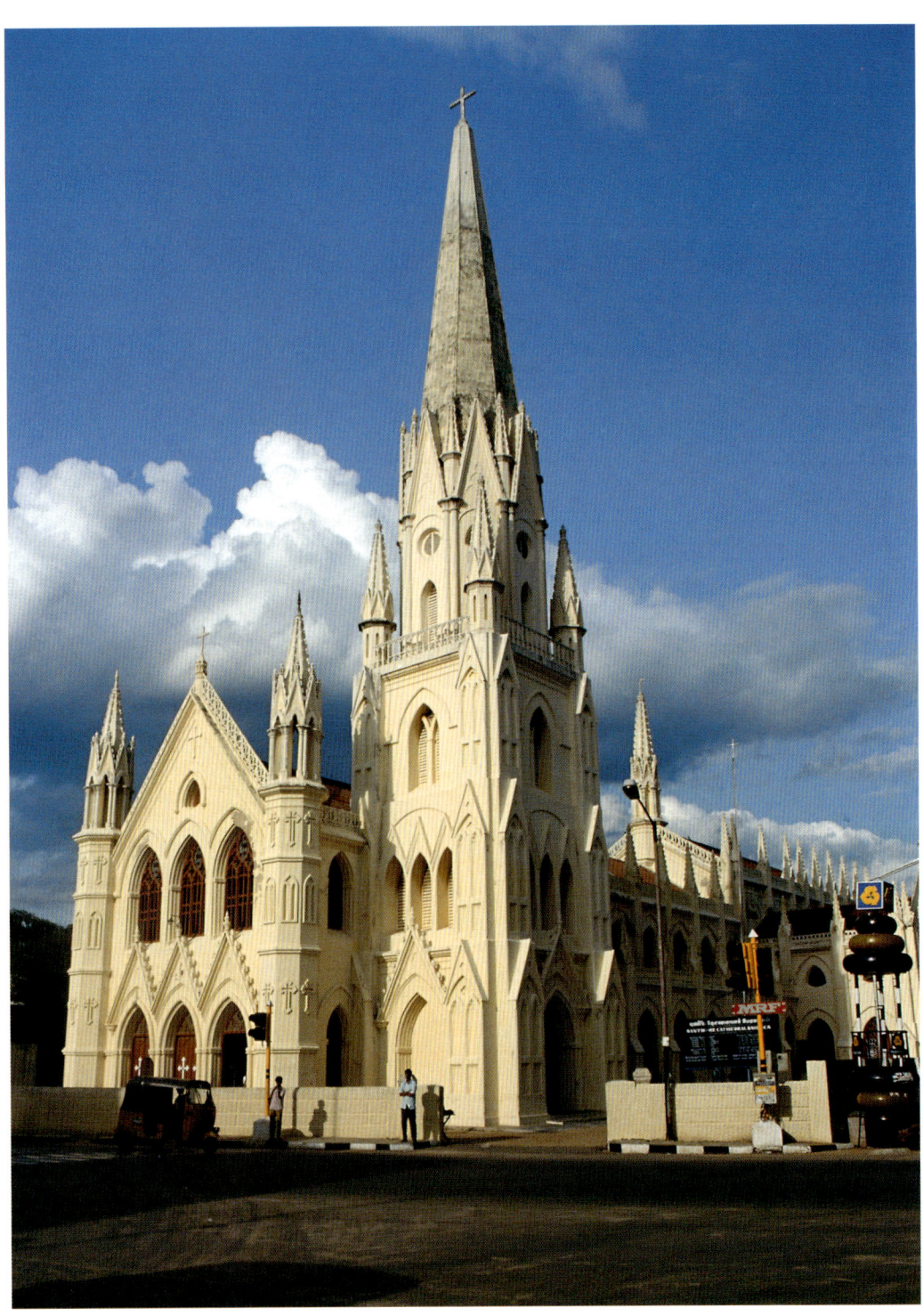

Basilica of San Thome in Chennai. *Opposite page:* The Basilica of San Thome is also the burial place of St. Thomas (Doubting Thomas), an apostle of Jesus Christ. The idol of Jesus Christ standing in a lotus flower and flanked by peacocks clearly shows Hindu influences of the region.

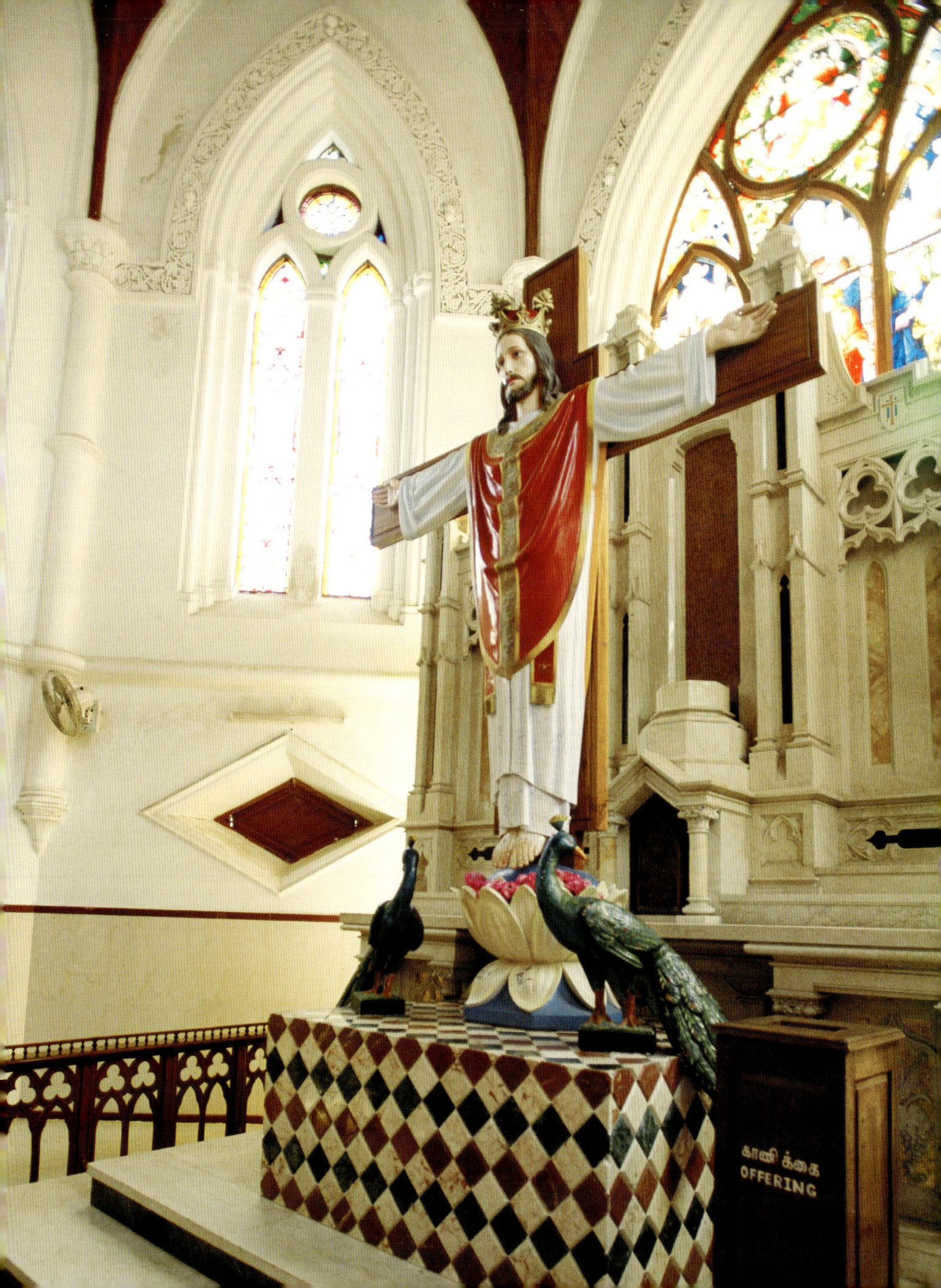

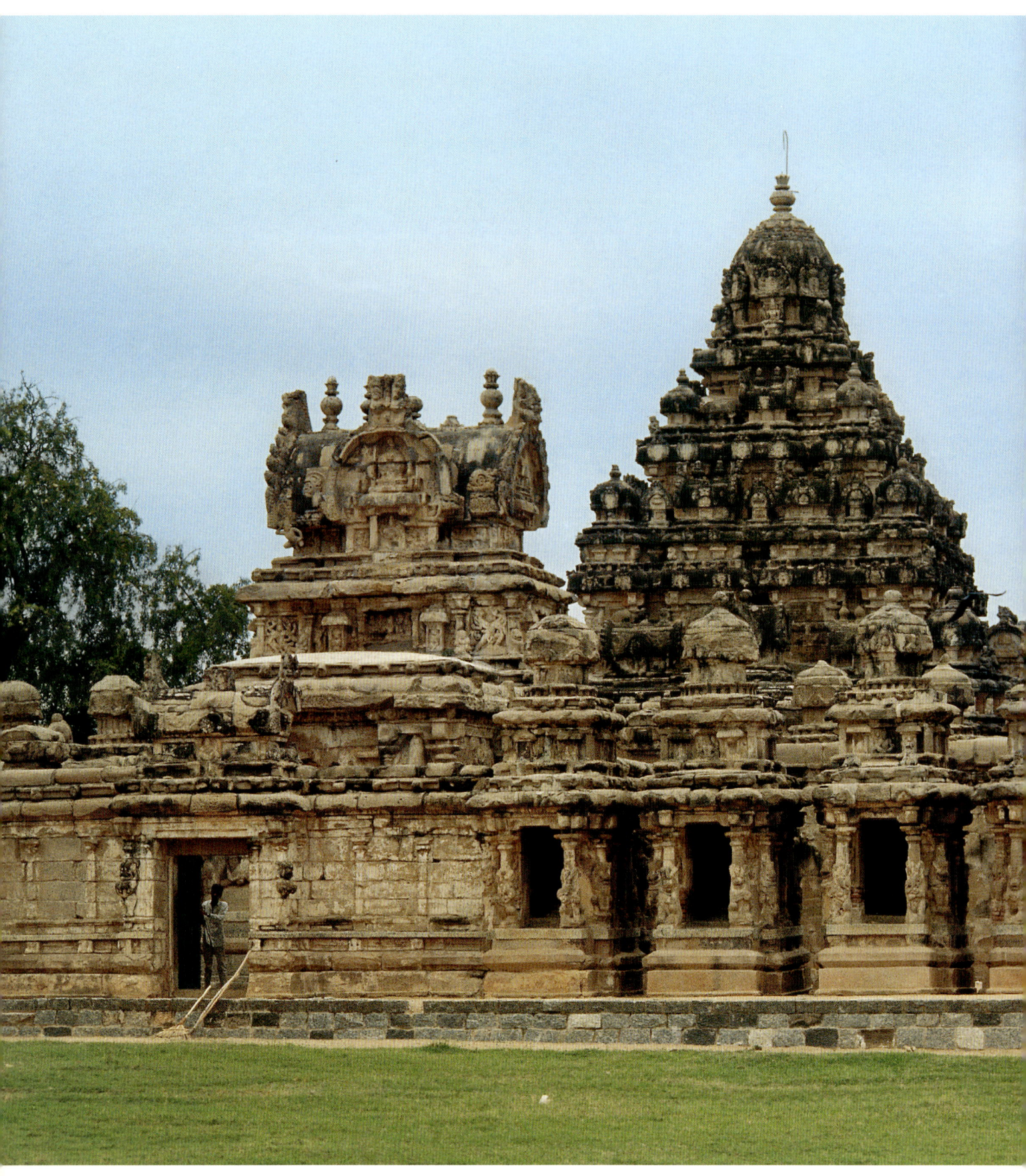

KANCHIPURAM

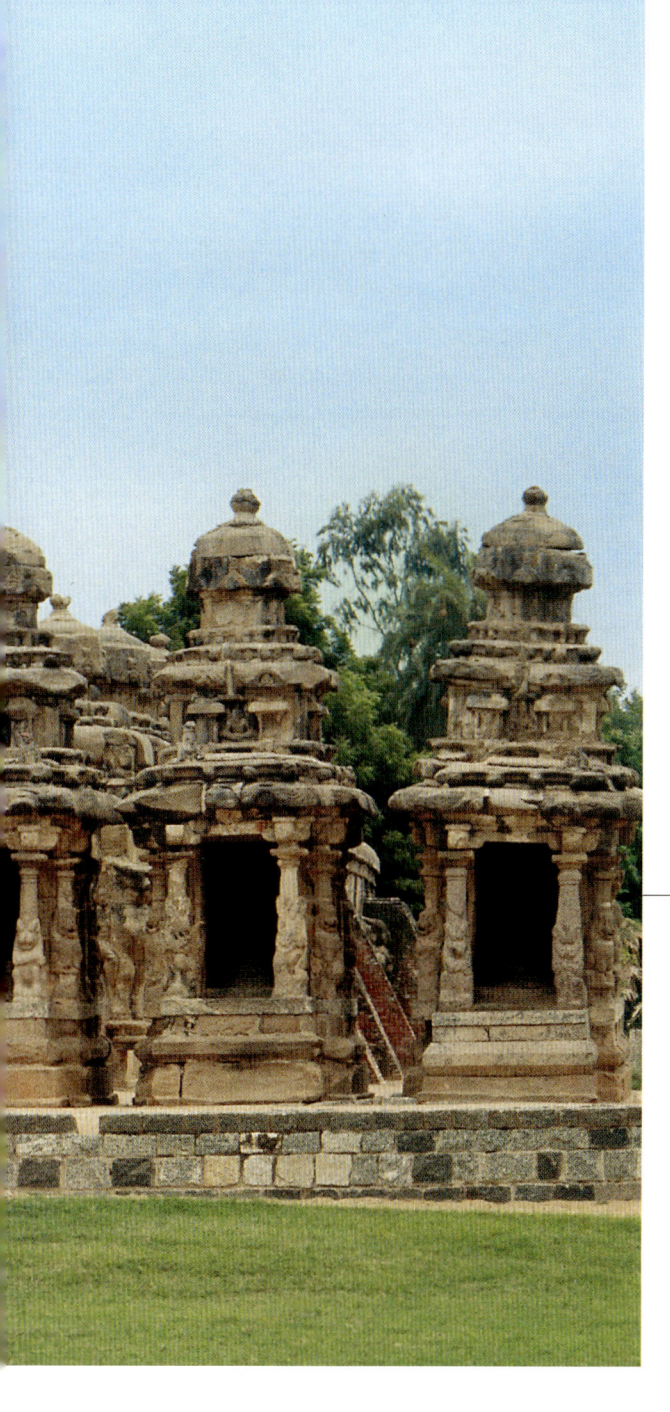

Kanchipuram is one of the seven holy cities of the Hindu pilgrim circuit; many also call it the Varanasi of South India, to drive home its importance. The city was founded by the great Pallava dynasty, which dominated the political scene of South India in the seventh and eighth century. The temple architecture spanning nearly a thousand years can be seen here. This "City of a Thousand Temples" boasts of temples dedicated to both Shiva and Vishnu.

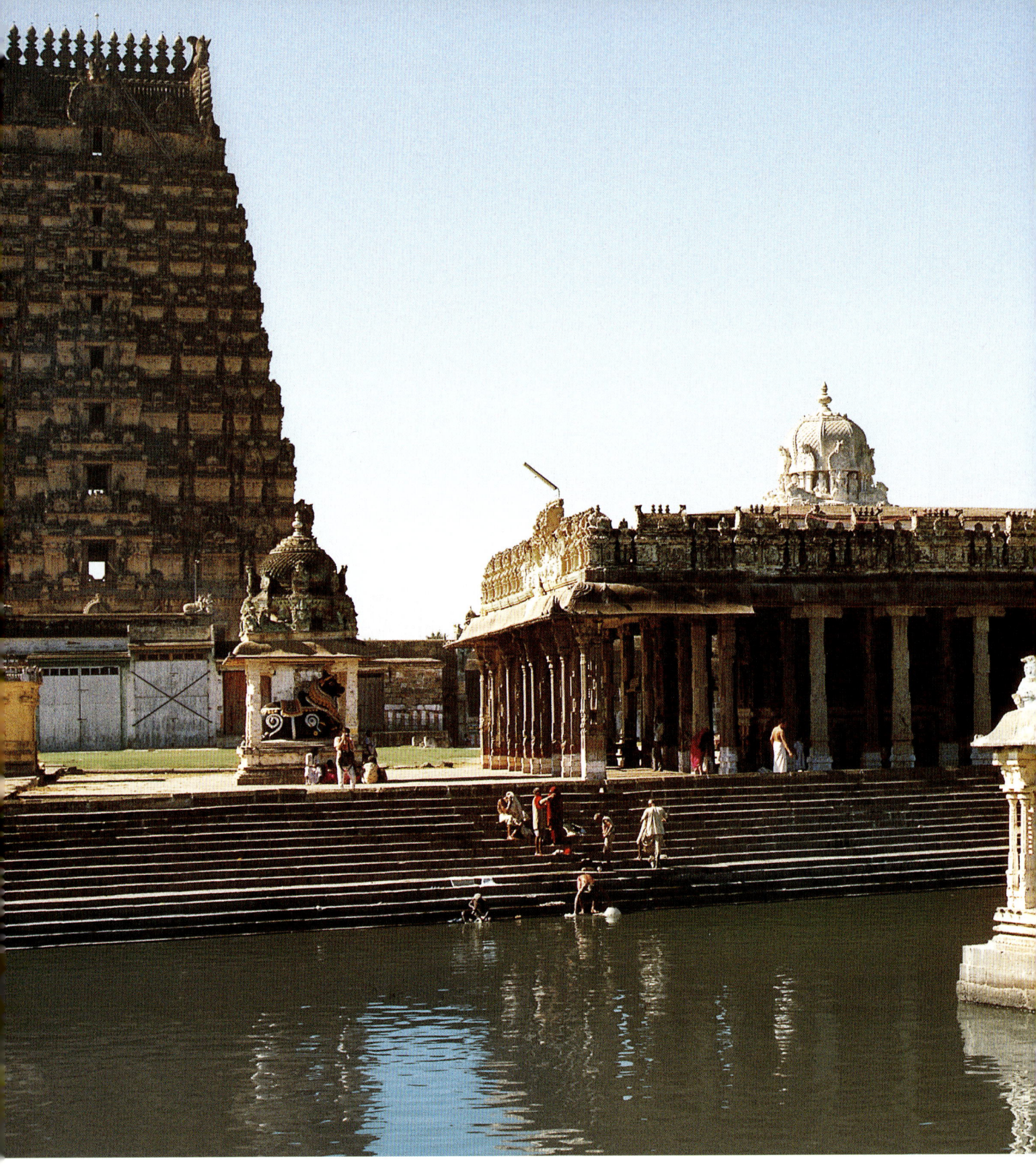

Water tanks are an important feature in the South Indian temple architecture, as these are used by the pilgrims to purify themselves before visiting the temple. The 12th century Ekambaresvara Temple can be seen in the background.

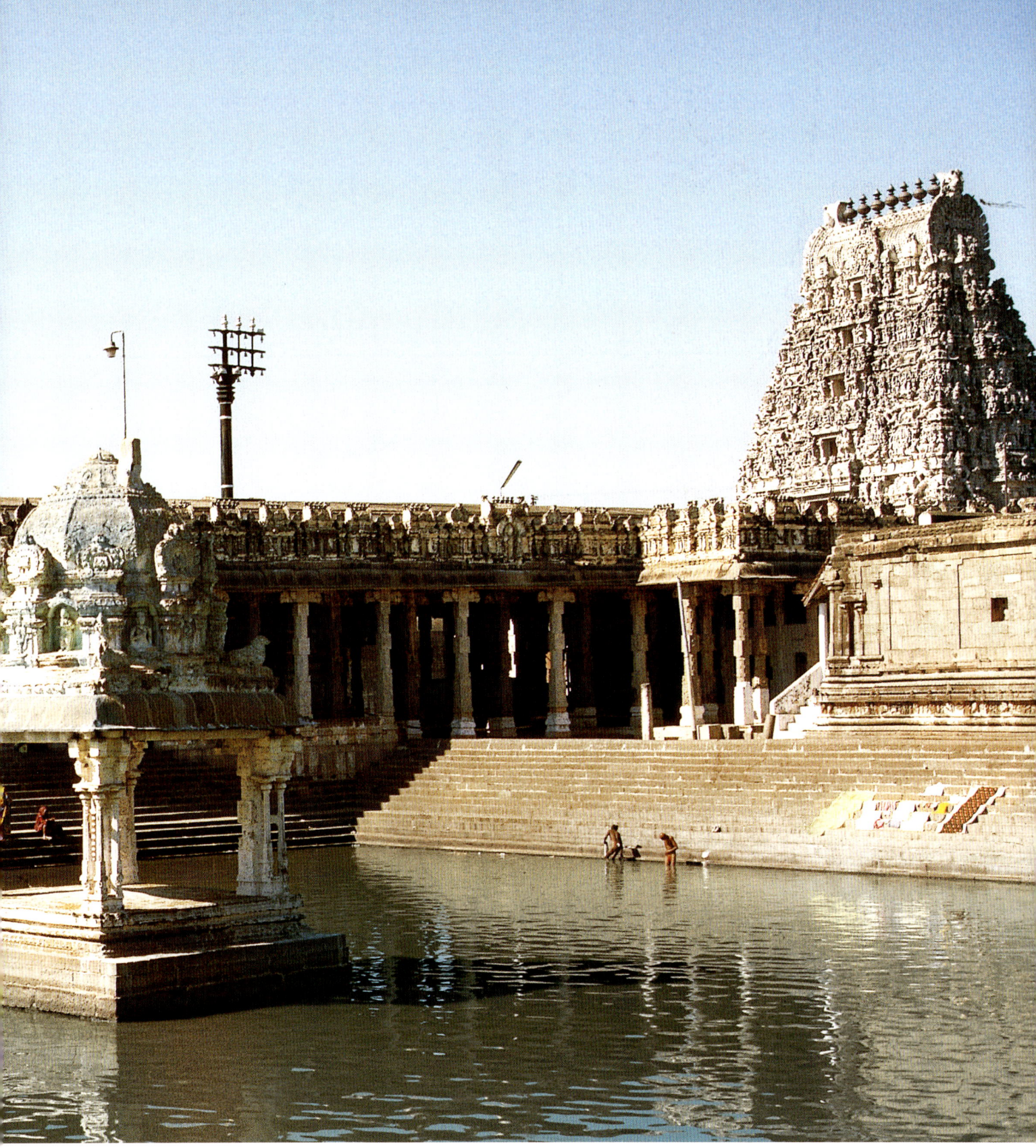

Page 20: The Kailasanatha Temple in Kanchipuram was built by the Pallava king Narasimhavarman II in the seventh century. *Page 21:* Wish granting mango tree, said to be more than a thousand years old and still bearing fruits, can be seen in the compound of the Ekambaresvara Temple, Kanchipuram.

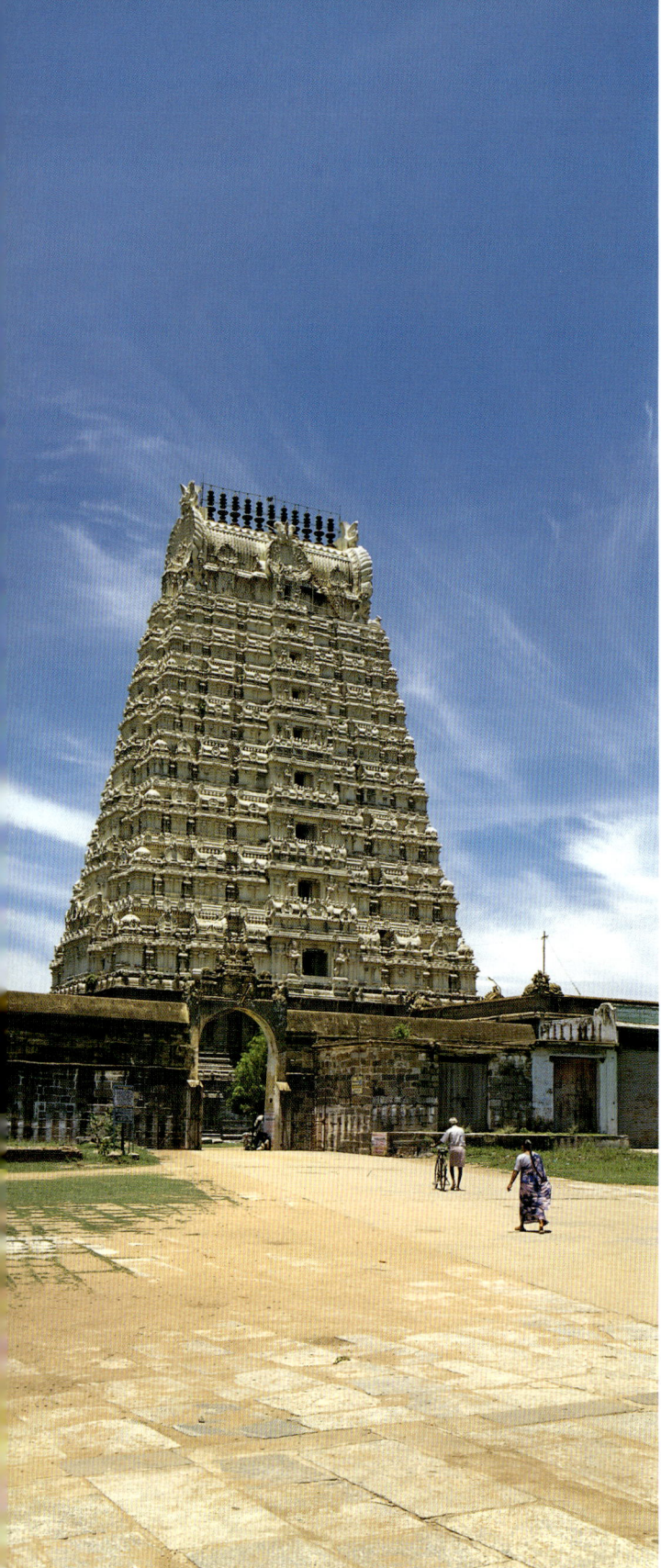

The Kailasanatha Temple, dedicated to Lord Shiva, dates from 725 and was built during the reign of Rajasimha of the Pallava dynasty. This sandstone temple is remarkably well preserved despite the ravages of time. The main temple is not very big compared to the Ekambaresvara Temple; it is enclosed by a wall, which houses numerous shrines. It is surrounded by a landscaped garden, with Nandi, the bull who is Lord Shiva's vehicle, occupying centre stage. The area around this temple is a landscape of tranquil village life, with scenes of water buffaloes and ducks lazing in the village pond. The only noise that disturbs this tranquility is from the rice mills and that of the looms of the silk weavers.

The temple, which dominates the skyline of Kanchipuram is the Ekambaresvara Temple with its lofty gopurams, of which the tallest is two hundred feet high. Krishnadevaraja of Vijayanagar Empire built it in the sixteenth century. This Shiva temple has a long mandapa, or the entrance hall, lined with monolithic granite columns. Inside the temple, one can see giant animal shaped wood chariots on which the idols of the deity are paraded through the streets of the temple town during festivities in the months of March and April. Other noteworthy temples are Vardhmana Temple and Kamakshi Temple. The former dates from the Chola period in the twelfth century and is dedicated to Lord Vishnu. There is a beautiful mandapa (dance hall) on the edge of the tank. The columns are beautifully carved, especially the ones with the riders on horseback and of Rati, consort of Kamdev, Lord of passion, on a parrot. Kamakshi Temple is dedicated to Parvati, consort of Lord Shiva.

Kanchipuram, apart from being the temple town is also famous for its pure silk sarees. It is interesting to visit a weaver's hut and see some wonderful hues of silk yarn being transformed into intricate designs.

Soaring fifty-nine meters tall gopuram of the Ekambaresvara Temple in Kanchipuram worked as a landmark when pilgrims traveled on foot, as it could be seen from a great distance. **Opposite page:** The marriage hall of Varadaraja Temple, Kanchipuram is entirely supported by ninety-six exquisitely carved monolithic granite columns. The rider on the horseback also forms part of this monolithic marvel.

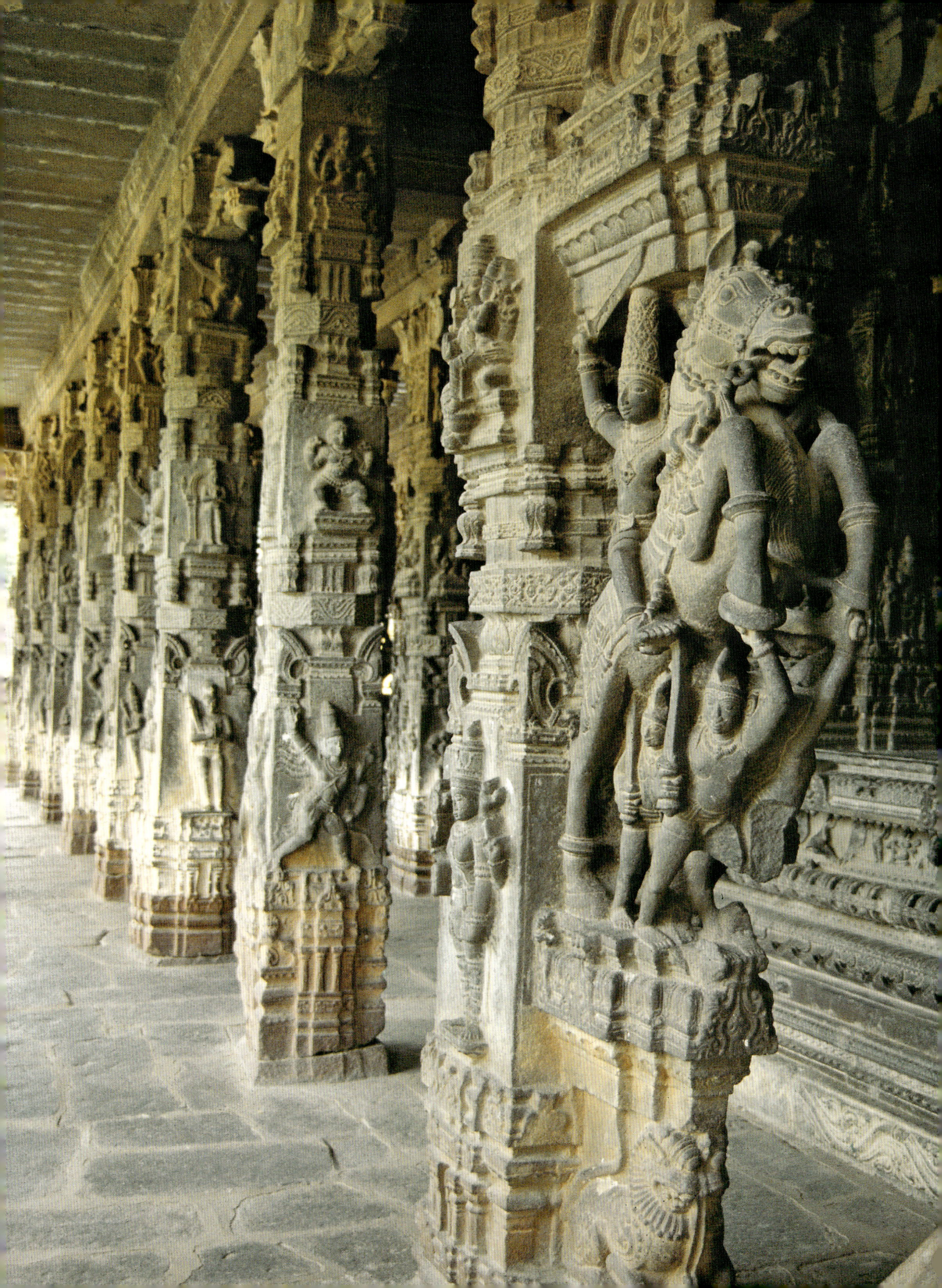

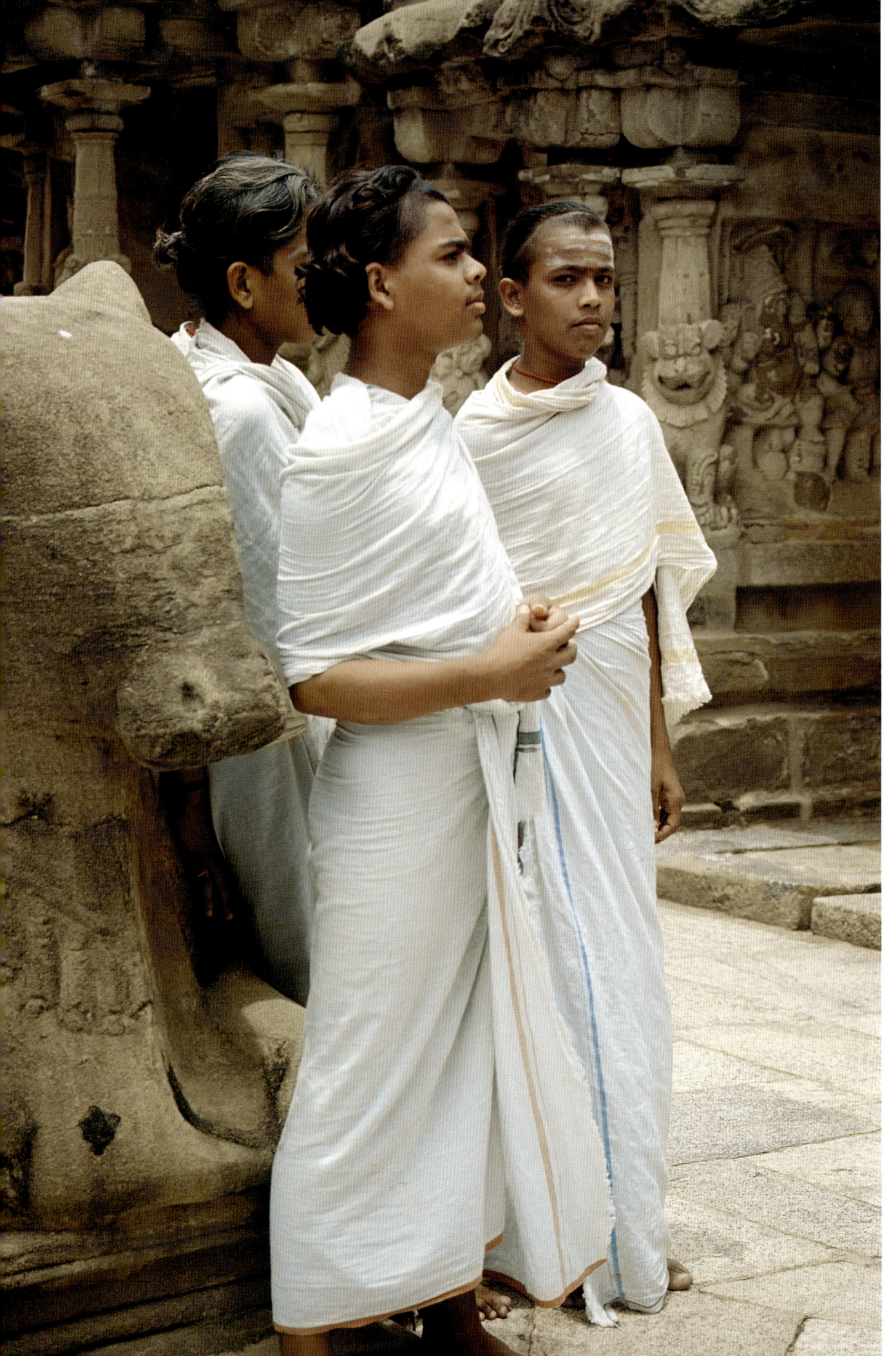

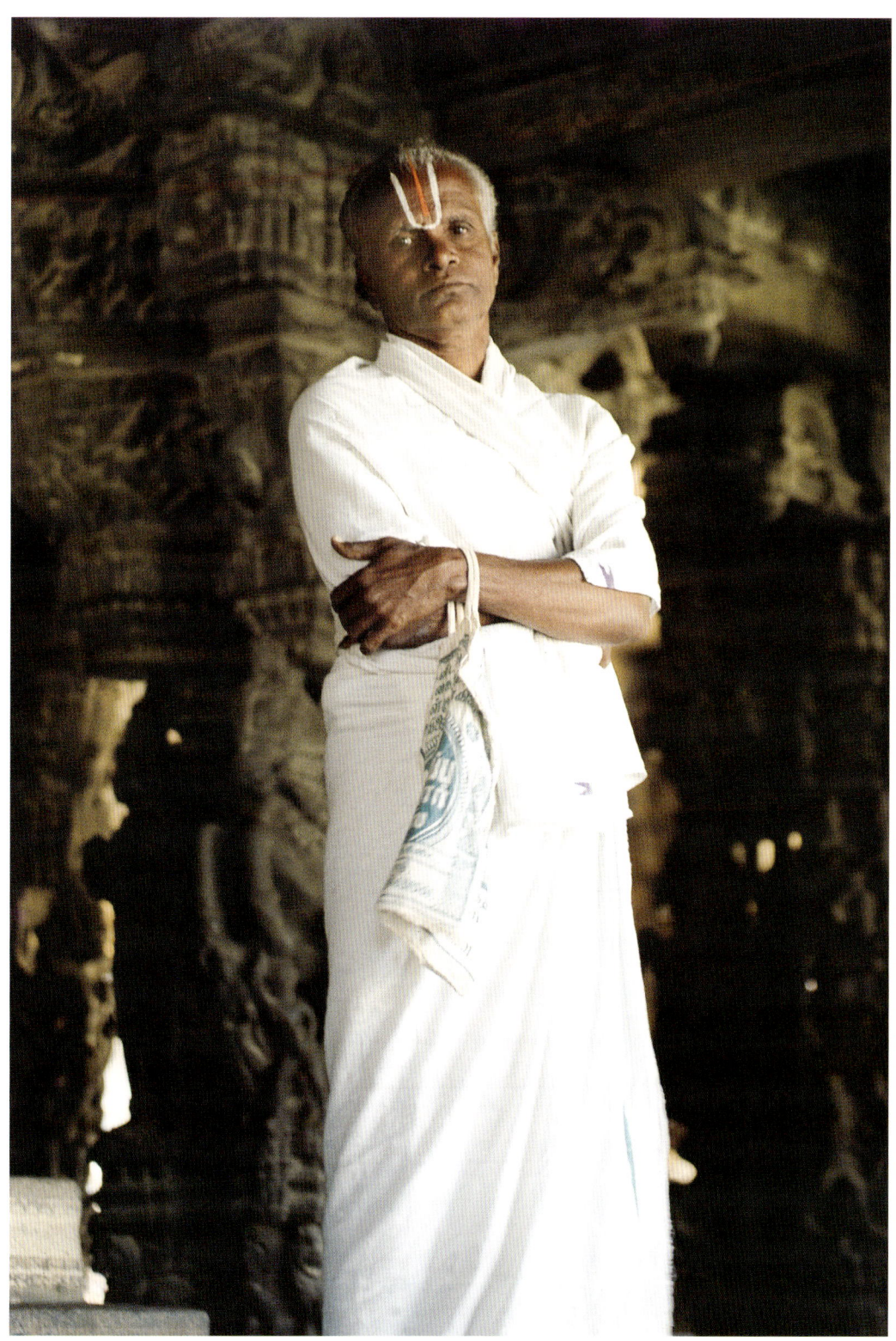

A priest of the Varadaraja Temple in Kanchipuram shows his affiliation to Lord Vishnu with the vertical lines on his forehead. **Opposite page:** Young Brahmin monks on a visit to the Kailasanatha Temple in Kanchipuram. The horizontal markings with sacred ash on their foreheads denote their status as followers of Lord Shiva.

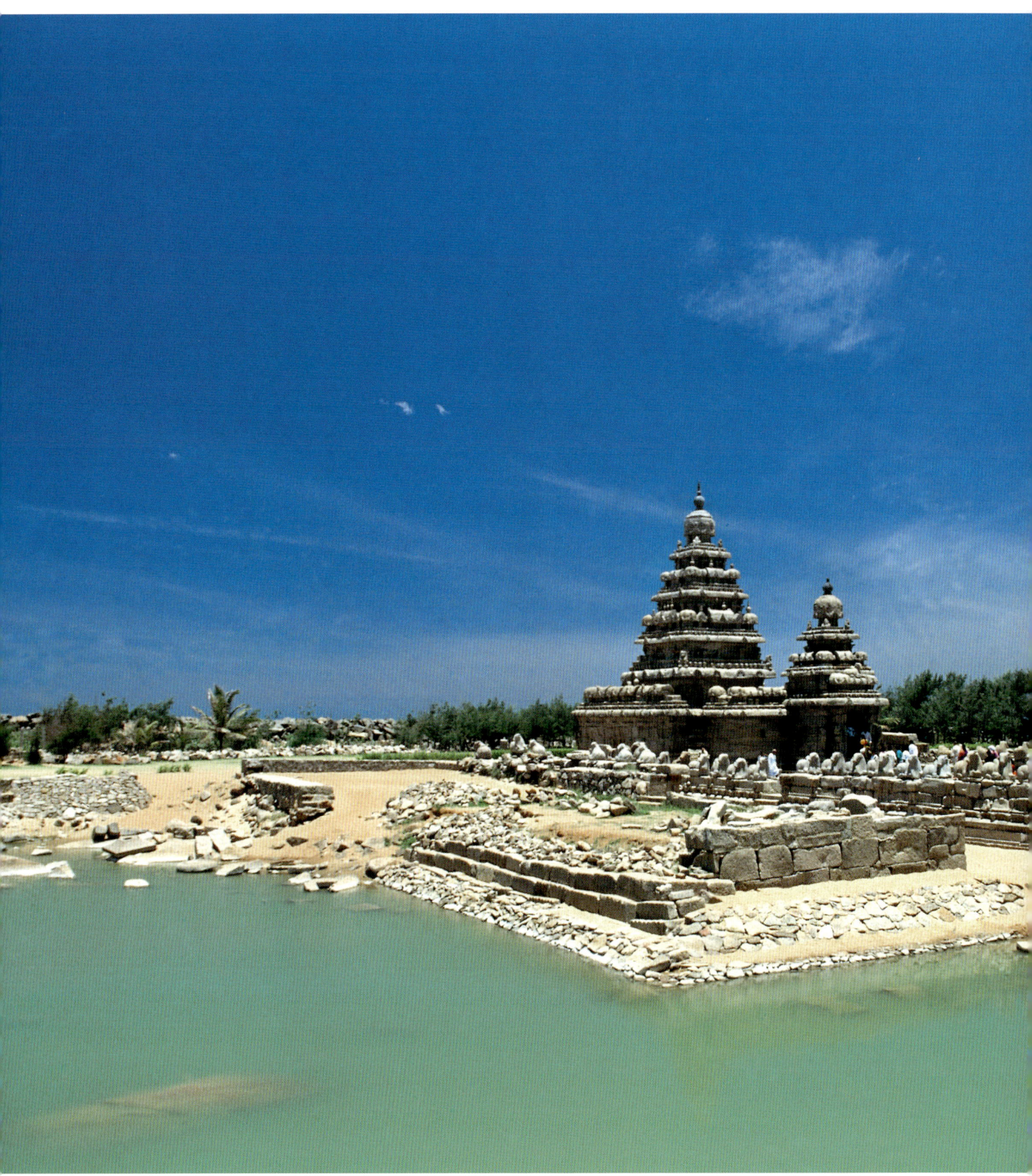

Mahabalipuram

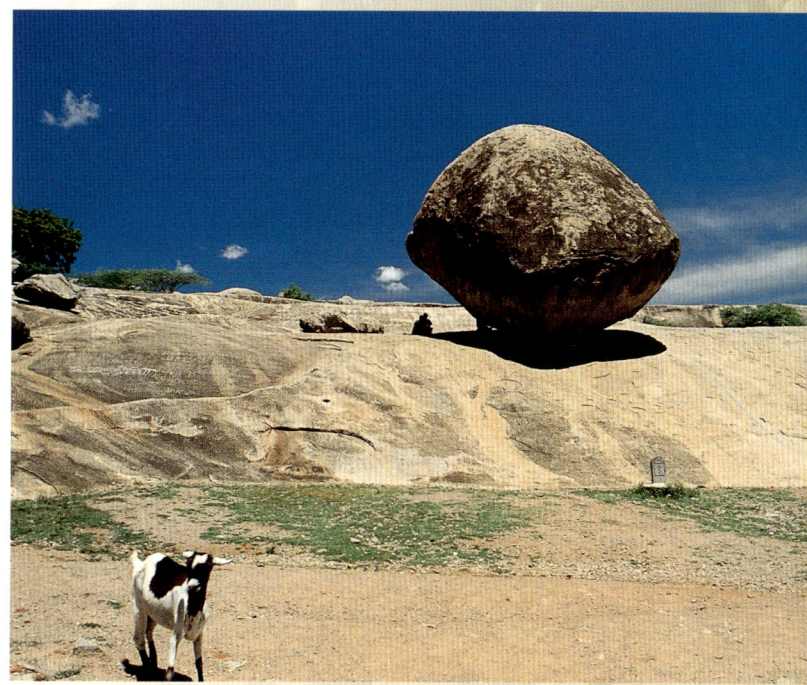

Mahabalipuram, or Mamallapuram as it is known now, was the port city of the Pallavas of Kanchipuram. The town is named after the Pallava ruler Narasimhavarman I who had excelled in wrestling, and was awarded the title of the great wrestler. The coastal village is more like an open-air museum. The monuments depict the evolution of the Dravidian style.

Temple architecture elsewhere in the South has been greatly inspired by its finely sculptured, rock-cut monoliths (seventy in number) of which the most notable are the Five Rathas

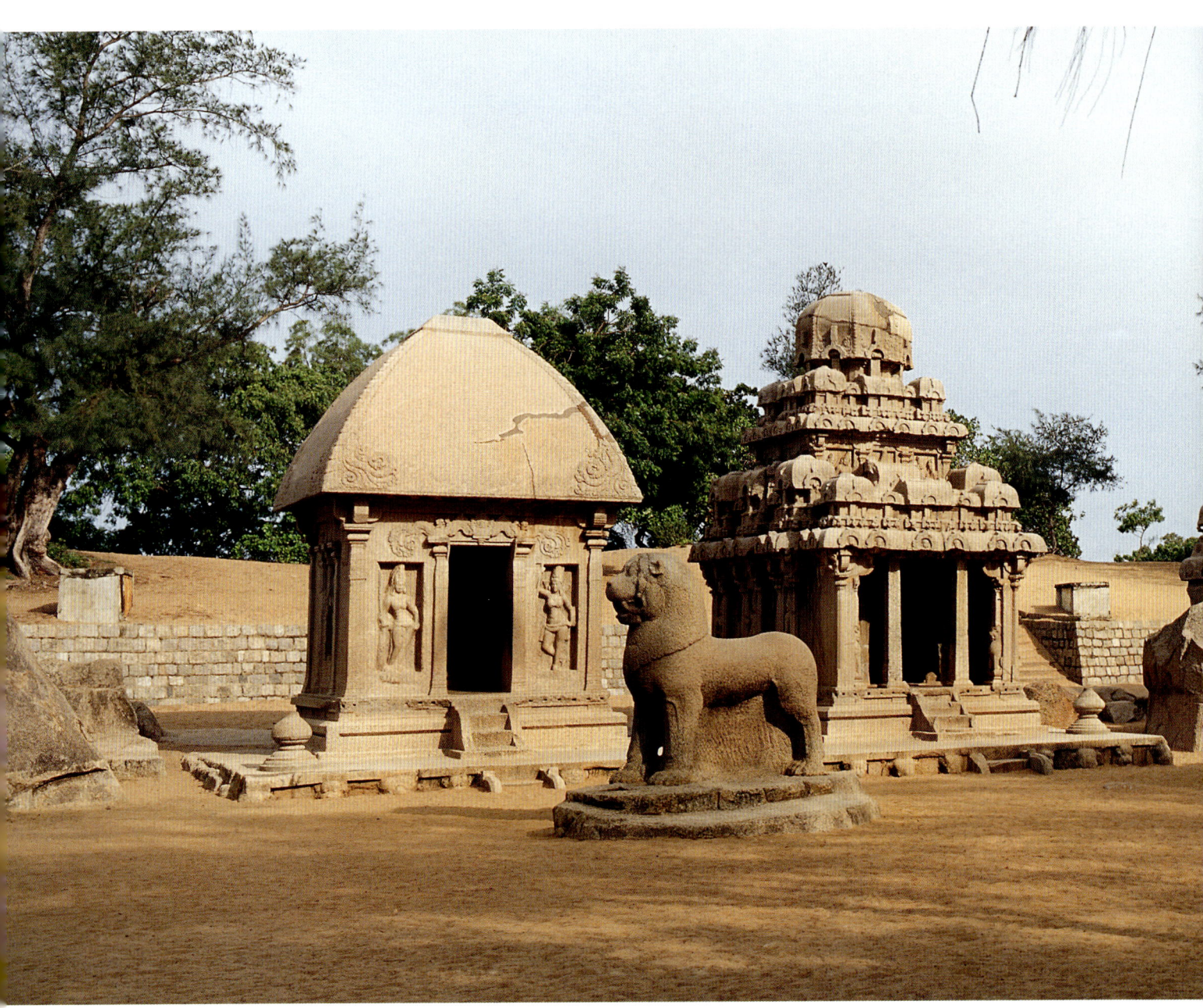

Five Rathas, or chariots as this group of monuments is known, are carved out of huge natural boulders. These monolithic structures represent the earliest evolution of the Hindu temple architecture from rock-cut to freestanding.

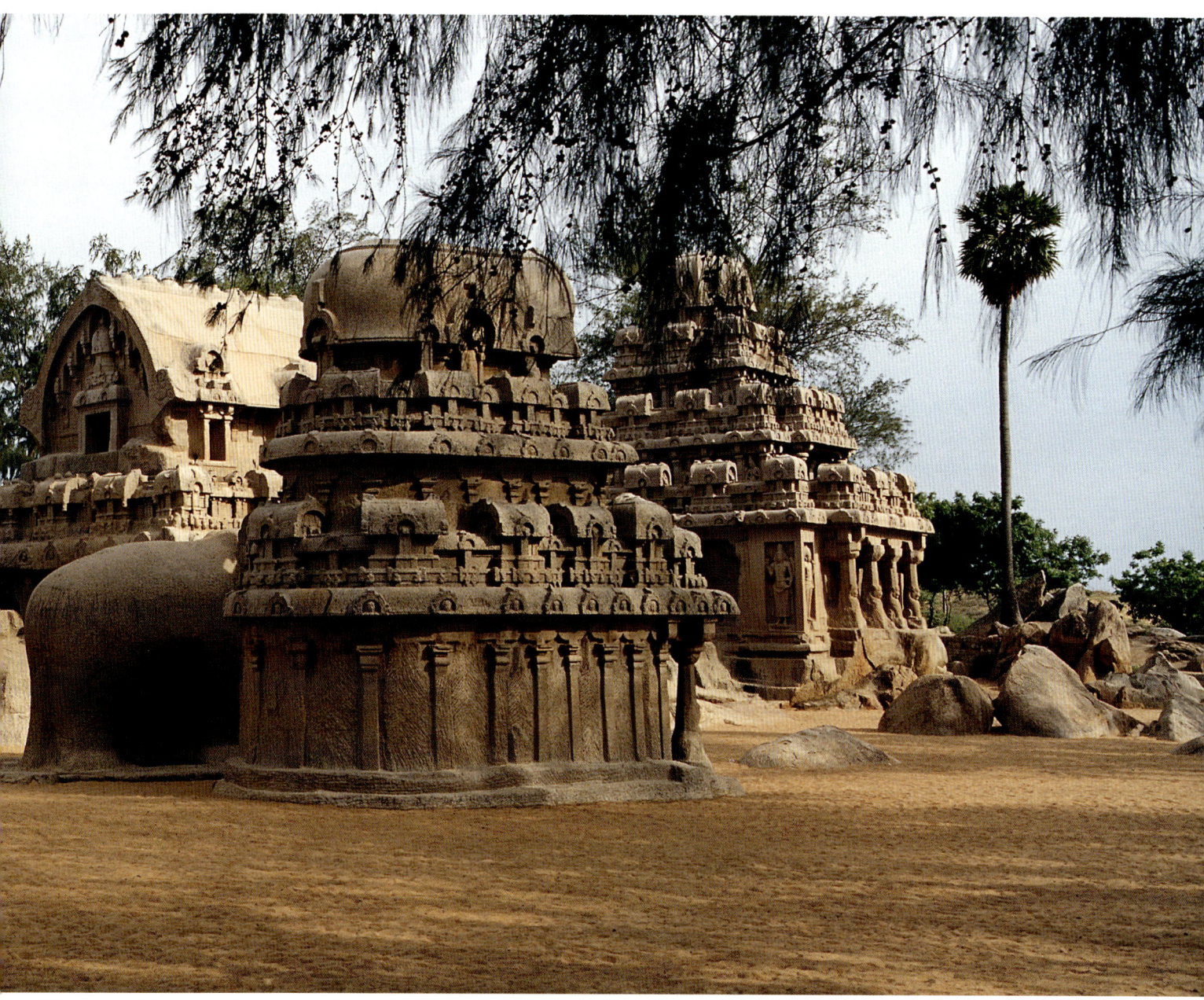

Page 28: Shore Temple at Mahabalipuram is a seventh century marvel which is beautifully set against the backdrop of the sea. It is unique in architecture as two temple towers that house both Shiva and Vishnu shrines are seen together. *Page 29:* A rock formation popularly known as Krishna's butterball hangs miraculously for centuries on the slope of a rock at Mahabalipuram.

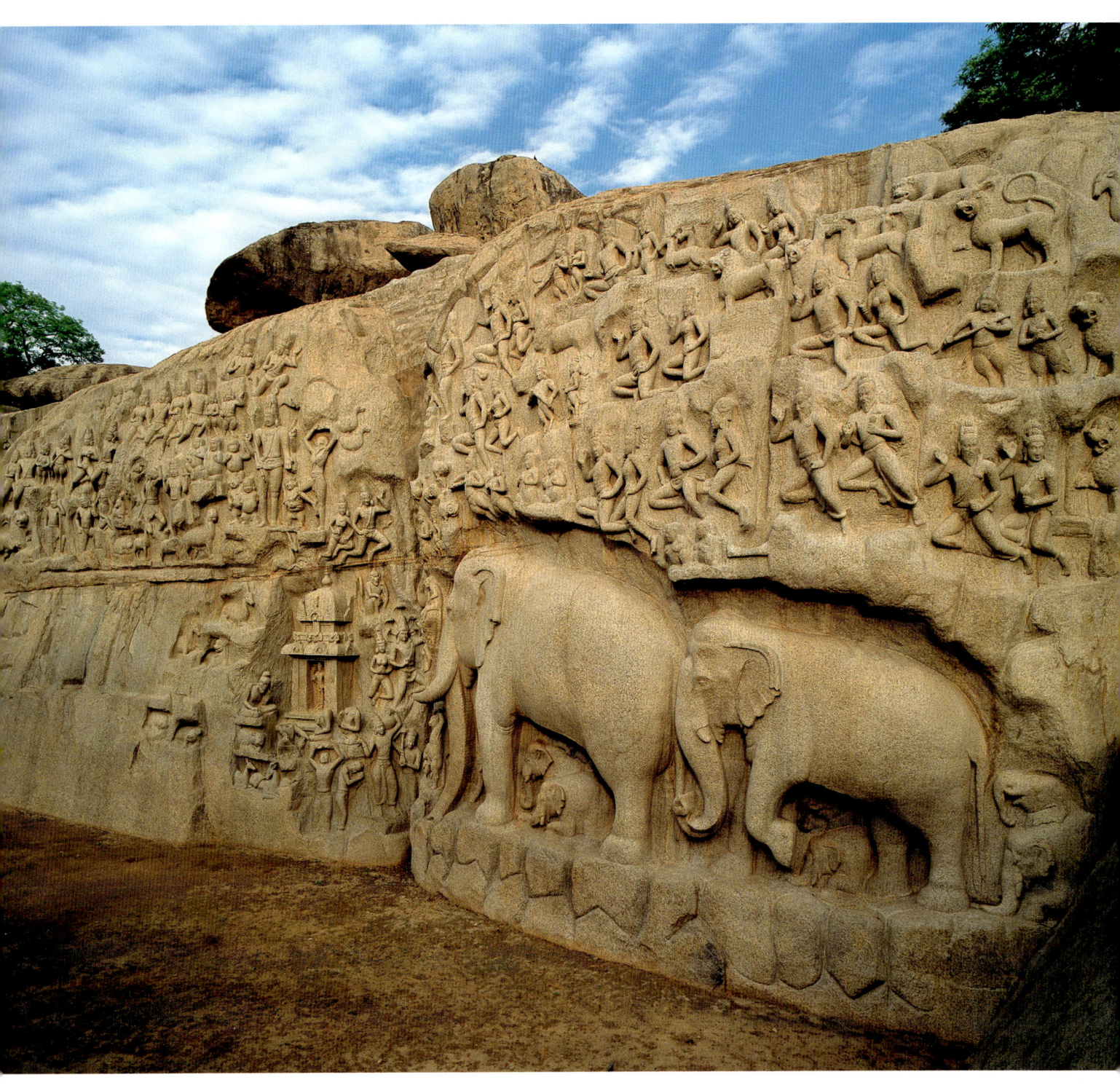

or chariots, named after classical Indian epic heroes of the Mahabharata. These date back to the seventh century and were built during the reign of Narasimhavarman I. They could have been the prototypes of the later style of temple building. Carved out of a single piece of natural rock, these incomplete works of art are arranged in a row like temple chariots in a procession. There are some very fine sculptures on the walls and columns of these temples.

The Shore Temple is a spectacular two-spired Pallava temple. Its similarity can be seen in the eighth century Kailasanatha Temple of Kanchipuram. It has shrines dedicated to both Vishnu and Shiva. The sea breeze down the centuries has taken its toll on the sculptures of the temple. One can still make out the scores of Nandi bulls, which decorate the surrounding walls.

The most spectacular monument of Mahabalipuram is the Descent of the Ganges or Arjuna's Penance. It is the world's largest bas-relief (80ft x 27ft) engraved on steep hillside. The sculptures on the rock face are a mixture of gods, yogis and animals and are depicted with great sensitivity. Originally there used to be a natural waterfall depicting Ganges in the narrow cleft of the relief, but it has since dried up. The yogi standing on one foot with his arms raised towards the heaven is believed to be Arjuna doing penance to obtain a boon from Shiva.

In another interpretation, he is identified as sage Bhagirath who requests Shiva to let the Ganges descend into his matted hair and from there onto earth and wash away the ashes of his ancestors, thus giving them liberation.

Mahabalipuram is a charming, laid-back place. All the major attractions are within walking distance, separated by the sculptors' workshops. The sounds of their chisel and hammer give the impression that the creative energy will never leave this coastal village.

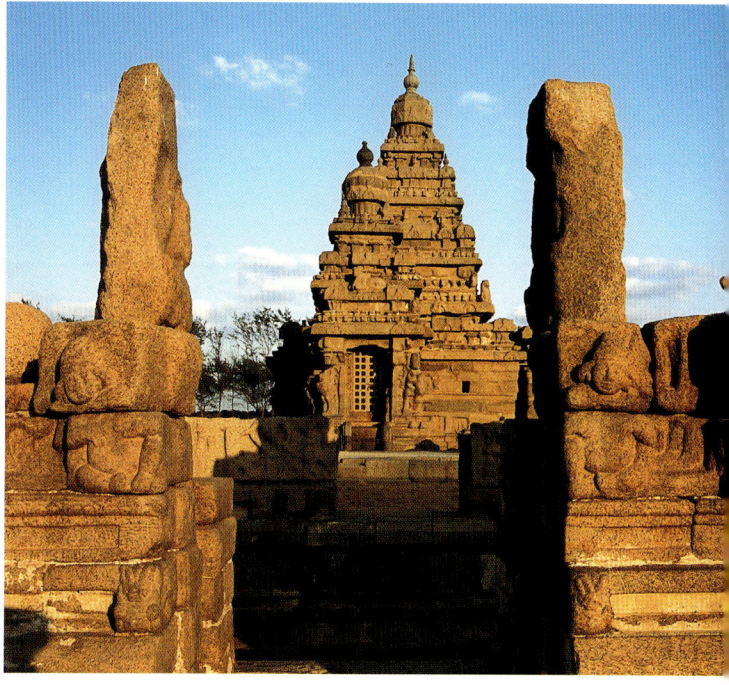

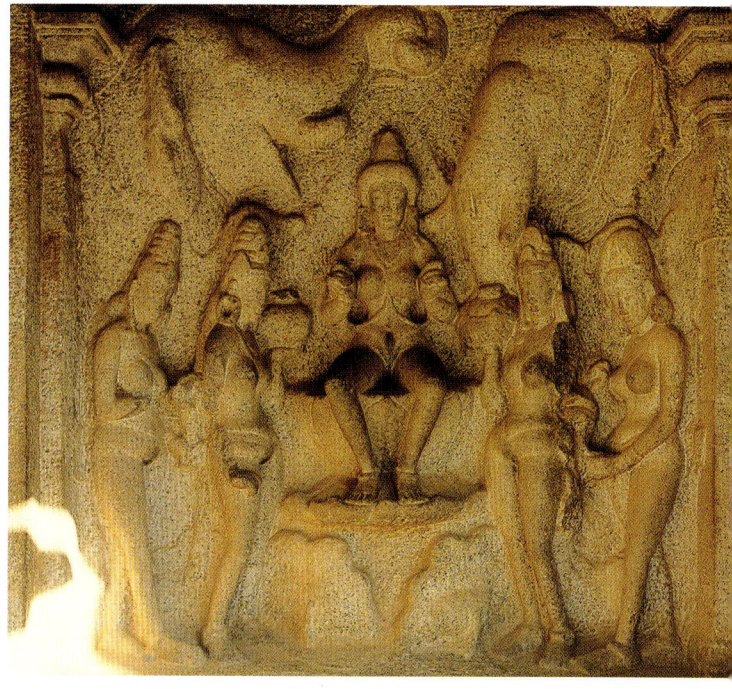

Above, Top: The Shore Temple looks magical at dusk. The eroded sculptures on the compound wall stand in mute testimony of this seventh century temple. **Above, Bottom:** Apart from the major attractions, there are numerous smaller rock-cut temples in Mahabalipuram that are dedicated to various divinities of the Hindu pantheon such as Laxmi, the goddess of prosperity. **Opposite page:** Arjuna's Penance is the world's largest bas-relief that shows animals, humans and deities carved into the side of two giant rocks. It also narrates the story of Bhagirath doing penance for the holy river Ganges to descend on earth.

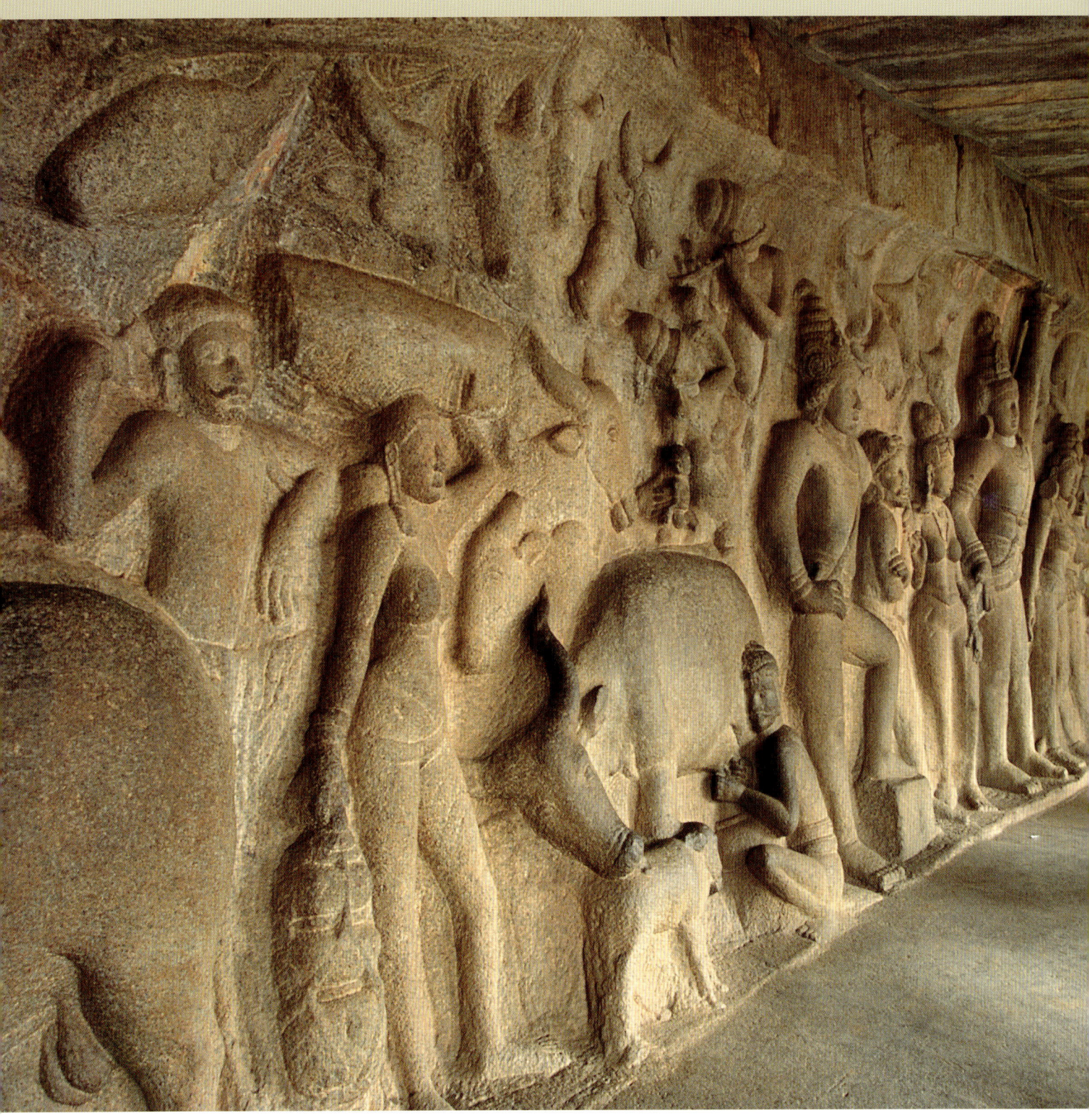

A magnificent bas-relief adjoining the Arjuna's Penance shows Lord Krishna with his arm raised, lifting mount Govardhan to protect the cows and people of his village from a deluge.

Above, Top: There are numerous stonecutters in the village of Mahabalipuram, who have kept the legacy of sculpting images from granite alive. ***Above, Bottom:*** Local girls at the temple site.

SOUTH INDIA 35

Pondicherry

Pondicherry, the former French colony, is also known as the French Riviera of the East (La Côte d'Azur de l'Est). It was an important trading post that was mentioned in the navigational charts of Periplus of the Erythraean Sea. Archaeological excavations have revealed Roman pottery dating back to 1st century A.D. (showing its importance as a trading post in the Roman Empire). A remarkable degree of French influence is still entrenched in Pondicherry.

Page 36: Flowers are an important element in the daily life of the people of South India. The flower market of Pondicherry is an exciting place to wander around and take in the sights and smells of the multitudinous variety of flowers. **Page 37:** Flower seller with his son seems to be enjoying their moment.

The city was designed based on the French grid pattern and features boulevards and streets intersecting at right angles. The entire town is divided into two parts, the French quarter (Ville Blanche or 'White town') and the Indian quarter (Ville Noire or 'Black Town'). Many streets still retain their French names and French style villas are a common sight in Pondicherry. The use of French language is still quite prevalent in Pondicherry, you can hear the locals holding animated discussions in fluent French at the bars and public places. French is still used for all official and educational purposes.

Pondicherry has a large number of Tamil with French passports, these are descendants of those who chose to remain French when the ruling French establishment presented the people of Pondicherry with an option to either remain French or become Indians at the time of Pondicherry's independence.

There is the French Consulate in Pondicherry and several cultural organisations, such as 'Le Foyer du Soldat', a Legion hall for soldiers who served in the different French wars. The other cultural organisations of note are the French Institute of Pondicherry, the Pondicherry Centre of the École française d'Extrême-Orient and the Alliance Française. A French-medium school system, the Lycée Français de Pondichéry, continues to operate under the support of the French Minister of National Education.

Pondicherry has a special political privilege; it is a Union Territory that is governed by the central government and not by the state in which it is located. It enjoys many benefits because of this, lower taxes and lenient excise laws being among the few. The Centre is represented by the Lt. Governor, who resides at 'Le Palais du Gouverneur', the former palace of the French Governor.

Above, Top: Flower merchant office decorated with calendar prints of Hindu divinities. **Above, Bottom:** A market scene in the street of Pondicherry. **Opposite page, Top:** French influence can be seen everywhere in the ancient French colony of Pondicherry, even the policemen keep the tradition alive with French beret. **Opposite page, Bottom:** The golden globe of Matri Mandir is used as a meditation hall and houses the world's largest crystal. The amphitheater in the foreground is made from sand, which was brought from all the nations of the world.

SOUTH INDIA

Pondicherry is also an important spiritual center. One of India's greatest spiritualists, Sri Aurobindo, founded his world famous ashram here.

Auroville, an off shoot of the Aurobindo Ashram, is located 12 kilometers north of Pondicherry. It was founded by Mira Alfassa, a disciple of Sri Aurobindo, who later came to be known as the Mother. Auroville was inaugurated in 1968; earth from all over India and around the world was placed in the urn located in the center of the amphitheatre in front of Matri Mandir. Mother conceptualized it as a universal township where people are able to live in peace and progressive harmony regardless of their creeds, politics and nationalities, thus striving for realization of the ideal of human unity.

The highlight of Auroville is definitely the Matri Mandir. It is unique in architecture, which is shaped like a massive spherical ball made out of concrete beams, giant circular convex brass plates placed all over it. Inside in the centre of this colossal sphere is the meditation hall where a huge Zeiss crystal ball is placed, the shaft of light entering through the opening of the sphere on top enters to illuminate it and disperses into the surrounding area. The populace of Auroville sit around this aura of light to meditate.

In literature too, Pondicherry has made its mark; it was the setting for the Booker prize-winning novel 'Life of Pi" by Yann Martel. Lee Langley's novel 'A House in Pondicherry' was likewise set there. The promenade comes alive in the evening with locals and numerous vendors, some interesting colonial buildings such as the Custom House line this ocean front.

The Jesuit Cathedral in Pondicherry. **Opposite page:** Ripened bananas sit dramatically against the blue door in the fruit market of Pondicherry.

SOUTH INDIA

Swamimalai is an ethnic village resort located in the heart of Tamil Nadu, which provides an insight into the village life of the region.
Opposite page: The reception area of Swamimalai is decorated in ethnic fashion with artifacts of the region.

Chidambaram

A couple of hours drive along the coast, south of Pondicherry, is Chidambaram. This temple town is of great religious, historic and cultural significance in the South. It is unique in its stature as the bejewelled image of Shiva is housed in the dancing pose – Nataraja, the king of dance. Usually, Shiva is represented in lingam form in the temples. According to the Hindu traditions, Chidambaram is one of the five holiest Shiva temples where the Lord is also represented by the natural element or 'Akasa Lingam', a personification of Shiva as the formless space.

The gopuram of the Nataraja Temple in Chidambaram is decorated with numerous stucco figurines depicting the stories from Hindu mythology.
Page 44: The view of the Sivaganga Tank in the Nataraja Temple of Chidambaram. **Page 45:** A local astrologer cum palmist waits for clients at the temple entrance. The Shiva Temple of Chidambaram is the only place in the world where the almighty is represented in his cosmic dancer avatar.

SOUTH INDIA

The origins of this vast temple complex are buried in antiquity. Tradition of Shiva (Nataraja) worship has been mentioned in the literature of Sangam period that corresponds to 1st-3rd century A.D. The later Chola kings adorned the sloping roof of the shrine with gold in 9th and 10th century; this feature is unique in temple architecture of South India and is not seen anywhere else. Chola dynasty treated Nataraja as their guardian deity and made liberal donations to the temple as the inscriptions testify. The Pandya kings and the later Vijayanagar rulers, who followed the Cholas, continued with the tradition of being the benefactor of Chidambaram Temple. In the 18th century, this temple was used as a fort, when the British General Sir Eyre Coote unsuccessfully tried to capture it from the Mysore kings. During this period, the images of Nataraja and Sivakamasundari (Shiva and Parvati) were housed in the Tiruvarur Tyagaraja Temple for safety.

The legend of the temple states that Seshnaga, the serpent (who forms the bed of Lord Vishnu), heard from his master the grandeur of Shiva's cosmic dance. Filled with the desire to witness this spectacle, Seshnaga descended to the earth as Patanjali (the one who descended). At the appointed hour, Shiva granted to Patanjali and Vyagrapaadar, a visual treat in the form of his Cosmic Dance of Bliss, to the accompaniments of music played by several divine personalities in the Hindu pantheon. This Dance of Bliss is said to have been witnessed by Vishnu, and there is a Govindaraja shrine in the Nataraja Temple commemorating this.

Yet another legend, commemorating the dance duel between the doyens of dance Shiva and Kali, is associated with Chidambaram. Shiva is said to have lifted his left foot towards the sky in the Urdhva Tandava posture, which his consort Kali could not reciprocate in her modesty, because she would have had to lift her dress to do so thereby, letting Shiva

Above, Top: The guardian of the temple, flanked by peacocks, keeps the vigil in all cardinal directions. **Above, Bottom:** Nandi, the vehicle of Lord Shiva, guards the temple premises with a watchful eye. Installation of Nandi bull on the walls of the temple denotes that it is Shiva's shrine.

emerge victorious. This legend is portrayed in the Nritta Sabha, one of the halls within the Chidambaram Temple, and also in front of the Sundereshwar shrine in the Meenakshi Temple of Madurai.

Nataraja, the Dance of Bliss, or the Ananda Tandavam of Shiva is said to symbolize the five divine acts; creation, sustenance, dissolution, concealment and bestowment of grace.

The innermost sanctum of the temple, the Chit Sabha or the hall of consciousness, is a wooden structure supported with wooden pillars, with a hut shaped roof. It is the holiest shrine in the temple and houses the images of Shiva and Parvati. Adjoining it is the Kanakha Sabha, or the hall with the golden roof. Across from the Nataraja shrine is the Nritta Sabha or the hall of dance with magnificent monolithic columns.

Ceilings on the mukhamandapam or the main hall of this temple have paintings from the Nayaka period. There are friezes of dancers, drummers and musicians all along the enclosing walls of this temple. The thousand pillared hall is designed in the form of a chariot that is pulled by two elephant sculptures at the entrance.

The magnificent structures of the temple are the four lofty gopurams or towers in the four cardinal directions, piercing the walls of the outermost prakaram. Each is a gigantic masterpiece in itself — about 250 feet in height, with seven tiers. The Western tower is the oldest one. In the towers, on either side of the gateways, there are representations of the 108 poses of the classical Bharatanatyam tradition as enunciated in the Classic Natya Shastra. The towers are embellished with images from the Hindu mythology. Six worship services are offered in this temple each day at the shrine of Nataraja — the last of which is the Ardha Jaama Puja (the most special one), where the padukas (footwear) of Nataraja are ceremoniously taken to the Palliarai (night chamber) of Shiva and Parvati after elaborate rituals. It is believed that the entire pantheon of divine figures in the Hindu system of beliefs is present during this occasion.

Temple priest with his traditional dress called dhoti and sacred ash markings walks in the temple premises. Three horizontal bands of sacred ash on his forehead and torso declare his status as the follower of Lord Shiva.

Gangaikondacholapuram

Rajendra I of the Chola dynasty built a temple in the village of Gangaikondacholapuram in the eleventh century. It commemorates his successful campaign up to the river Ganga in eastern India.

Above and Page 55, Left: View of the temple from the garden with subsidiary shrine in the foreground. ***Opposite page:*** Dwarapala or the guardian of the door scares away evil spirits from entering the sanctum sanctorum. ***Page 50:*** The Brihadisvara Temple located in the sleepy hamlet of Gangaikondacholapuram, which was once a bustling town of the Chola emperors. It is one of the finest examples of the Chola dynasty temple architecture. ***Page 51:*** A beautiful life-size statue executed in the eleventh century, Gangaikondacholapuram Temple, shows Lord Shiva with his consort Parvati laying a wreath on his disciple.

SOUTH INDIA

Below, Right: The temple surface is covered with giant life size sculptures of divinities and their various attendants. ***Opposite page:*** A beautiful sculpture of Shiva as a wandering yogi on the temple wall.

The village too takes its name from this victory. On the outset, it looks like a replica of its namesake, the Brihadisvara Temple of Tanjore, but is much smaller in scale and size. There is a giant linga in the sanctum below the giant vimana. The temple walls have beautiful sculptures of Hindu divinity. The most beautiful one is at the north entrance, where Shiva seated along his consort Parvati is bestowing a wreath on Chandesha. There are smaller shrines in the compound and a giant Nandi at the entrance. The temple is set in a beautiful landscaped garden, maintained by the archaeological department.

Darasuram

Airavatesvara Temple at Darasuram is attributed to Rajaraja II, who built it in the twelfth century. Although smaller in size than the other two Chola temples, Darasuram is described as a sculptor's dream in stone.

Airavatesvara Temple is a twelfth century gem of the Chola temple architecture. The balustrades for the flight of steps approaching the mandapa from the south are beautifully decorated on the outer side with long curling trunk issuing out of a lion-head. The vimana of the temple towers at the far end.
Opposite page, Left: A smaller Chola temple adjacent to the Airavatesvara Temple. **Opposite page, Right:** The walls of the Airavatesvara Temple were painted with vegetable dyes. Only a fraction of original paintings that once covered the entire temple, has survived the ravages of time.

Page 56: The ornamentation on the outer walls of the Airavatesvara Temple is dominated by flower corbelled pillars, which are interspersed with exquisitely carved black granite statues of divinity. The architecture is inspired by the wooden buildings that were in vogue at that time; Shiva as Dakshinamurti on the southern façade of the temple. **Page 57:** Women praying to the idol of goddess Parvati, the consort of Lord Shiva, on the northern face.

The proportions and grace in the figures is unsurpassed in the south. The front mandapa itself is in the form of a huge chariot drawn by horses and elephants. The columns are carved out of a single block of granite and depict mythological stories. In front of the temple are stone panels, which produce musical notes when struck. The paintings on the roof in the small museum of the temple are simply exquisite.

The monolithic temple columns at Darasuram are sculpted with heavenly dancers and narrative engravings of Hindu mythology.
Opposite page: Airavatesvara Temple at Darasuram is a treasure trove for art and architecture. The numerous carvings depict not only the divine and their stories but also daily life of the twelfth century. The monolithic stone columns with yali (the mythological lion) at the bottom are truly captivating.

Tanjore

Tanjore, Gangaikondacholapuram and Darasuram are the three gems of Chola architecture. Their sheer size and beauty reflects the power of the Cholas who held sway over the South for many centuries.

SOUTH INDIA

Tanjore or Thanjavur contains many exquisite temples of which the tallest ancient monument in India is the Brihadisvara Temple. This temple marks the zenith of the Chola architecture. The city attained prominence under the Cholas in the ninth century. The Brihadisvara Temple, dedicated to Shiva, is a symbol of the greatness of the Chola Empire under King Rajaraja I. The temple is the most ambitious of the architectural enterprises of the Cholas and a fitting symbol of the magnificent achievements of Rajaraja I whose military campaigns spread Hinduism to the Maldives, Java and Sri Lanka.

The Chola kings were great patrons of art, literature, sculpture, music and dance and majority of the temples in Tanjore have been built during their reign. Although all the ninety-three temples of Tanjore are beautiful in their own right, none command the majestic presence of the Brihadisvara Temple.

It is one of the most magnificent World Heritage monuments in the country. Its thirteen storeys, sixty-six meter high vimana or tower is the tallest in India and is topped by a dome carved from a block of granite, which is so cleverly designed that it never casts a shadow at noon throughout the year. The dome weighs eighty tons and is believed to have been hauled up a six kilometer long ramp.

The courtyard of the temple complex features an enormous Nandi guarding the entrance of the sanctuary. It is carved out of a single block of granite and is six-meters long. The main temple is constructed of granite and consists of a long-pillared hall, mandapa, followed by the ardhamandapa or half-hall, which leads to the inner sanctum or the garbha griha. The architecture, sculpture and paintings are all exceptional. Profuse inscriptions and beautiful sculptures of Shiva, Vishnu and Durga grace the three sides of the massive base of the shrine. There are detailed carvings of dancers showing eighty-one

Above, Top: The Brihadisvara Temple houses thousand lingas (phallus representation of Lord Shiva) in a corridor on the western wall. **Above, Bottom:** The walls of these linga chambers are decorated with paintings depicting the stories from Shivpurana. **Opposite page:** The smaller shrine in the fore court of Brihadisvara Temple houses a statue of Parvati, the consort of Shiva. **Pages 62–63:** Brihadisvara Temple is a tenth century Chola marvel that is accorded with World Heritage status. Its pyramidal vimana soars to the height of sixty-two meters and is topped by an eighty tonne granite stone.

A beautifully painted ceiling with indigo in the antechamber of the temple. ***Opposite page:*** The corridor located in the southwest corner houses giant wooden chariots, which are used to carry idols of the divinities around the city during the annual temple festival.

SOUTH INDIA

different Bharatnatyam poses and are the first to record classical dance form in this manner.

The passage surrounding the garbha griha contains some of South India's greatest art treasures, a frieze of beautiful frescoes of deities, celestials and dancing girls from the reign of Rajaraja I. These were hidden for nearly one thousand years under the Nayaka paintings from the seventeenth century.

A little away from the Brihadisvara Temple is the Royal Palace Compound, where members of the erstwhile royal family still reside. The Nayakas started construction of the palace in the sixteenth century and later it was completed by the Marathas. The Royal Museum near the entrance of the complex houses a small collection of manuscripts, costumes, musical instruments and weapons used by the royal family. Its Durbar Hall is of particular interest, which has some Chola bronzes on display.

The Saraswati Mahal Library in the palace is one of the most important oriental manuscript collections in India. It contains over forty thousand rare books, several of which are first editions. The majority of the manuscripts are in Sanskrit, including many on palm-leafs. The Tamil works include treatises on medicine and works from the Sangam period. There is a priceless collection of medical and botany books.

Tanjore is also famous for its bronze statues, Carnatic classical music and Bharatnatyam dance. Chola bronzes, a unique art form of Tamil Nadu have become popular enough to penetrate the world market. The icon of Nataraja, or the dancing Shiva, is one of the most recognizable Indian symbols.

The giant bronze flagstaff in front of the Nandi pavilion of the Brihadisvara Temple is decorated with lotus motifs above which is the engraving of Shiva with his consort Parvati riding the Nandi bull. **Opposite page:** View of the mighty Brihadisvara Temple, Tanjore (southeast).

SOUTH INDIA

The living room in the palace of the Maharaja of Tanjore is decorated with Tanjore paintings on the walls and thick teak wood beams support the roof.

Richly painted Durbar Hall or the Hall of Public Audience is executed in the sixteenth century Nayaka style paintings. The giant octagonal pillars support the lofty domes and the cusped arches showing influences of Islamic architecture.

SOUTH INDIA

TRICHY

Tiruchirapalli also known as Trichy is situated in the heartland of Tamil Nadu and lies in the Kaveri delta. The town is best known for the spectacular Ranganathaswamy Temple in Srirangam, a small village nestled on the island of the River Kaveri. A Chola fortification from the second century, it came to prominence under the Nayakas who built the dramatic Rock Fort and firmly established Trichy as a trading city.

However, owing to its strategic position, Trichy was always caught between warring factions. The Vijayanagar kings who in turn were overcome by the Muslims ousted the Cholas. Then came the Nayakas and after nearly a century of struggle against the French and the British, the town came under the British control.

The looming structure of the Rock Fort dominates the landscape of Trichy. The fort is built on a massive eighty-four meter high, sand-coloured rock. The Pallavas were the first to start construction with later additions made by the Nayakas. The entrance is from the China bazaar, a long flight of red and white painted steps cut steeply uphill, past a series of Pallava and Pandya rock-cut, to the Vinayaka Temple crowning the hilltop.

The Ranganathaswamy Temple at Srirangam, six kilometers north of Trichy, is among the most revered shrines of Vishnu in South India. The temple is famous for its superb structure, the twenty-one majestic gopurams and its rich collection of temple jewellery. The gopurams increase in size from the centre onwards. The exquisite central tower is the main attraction, which crowns the main sanctuary and is coated in gold and carved with images of Vishnu's incarnations on each of its four sides.

The temple town of Srirangam stands on an island in the Kaveri River and is surrounded by seven concentric walled courtyards, with magnificent gateways and several shrines. The outer three walls form the hub of the temple community where ascetics, priests and musicians stay. The fourth wall contains some of the finest and oldest buildings of the complex including a temple to the goddess Ranganayaki, where the devotees worship before approaching Vishnu's shrine. On the east side is the heavily carved thousand-pillared hall or Kalyana Mandapa, constructed in the Chola period.

A monolithic granite column depicting the mythological beast yali in the corridor of Ranganathaswamy Temple. *Opposite page:* The mighty gopuram marks the main entrance of the Ranganathaswamy Temple as seen from the main street. *Page 72:* Ranganathaswamy Temple dominates the skyline of Trichy with its twenty-one polychromatic gopurams. The golden dome denotes the location of the presiding deity of the temple complex. *Page 73:* Girl with smiling eyes sells flowers that are used as temple offerings by the faithful.

SOUTH INDIA

The monolithic granite columns with yali and Hindu saint motifs line the thousand-pillared hall within the Ranganatha Temple premises in Trichy.

Brahmin priests in their typical attire are eager to show you around the temple and perform religious rituals for a small fee. The thread worn across their torso marks their high caste status.

Sheshagiriraya Mandapa, south of the Kalyana Mandapa, features pillars profusely decorated with rearing steeds and hunters, representing the triumph of good over evil.

The dimly-lit inner shrine, the most sacred part of the temple, shelters the image of Vishnu in his aspect of Ranganath, reclining on the serpent Adisesha. The entrance to the shrine is from the south, but for one day each year, during the festival of Vaikunth Ekadasi, the northern gate is opened and is considered propitious for those who pass through it.

Most of the present structure dates from the fourteenth century, when the temple was renovated and enlarged after the Muslims attack. Spread over more than sixty hectares, the temple complex lacks any planning since different rulers between the fourteenth and the seventeenth centuries expanded it.

Original sixteenth century wall painting in the Ranganatha Temple in Trichy.

An entrance door of the secondary shrine within the Ranganatha Temple complex is covered with 24 wooden sculptures of Lord Vishnu devotees. The polychromatic stucco figures guard the door on either side.

SOUTH INDIA

Chettinad

Chettinad lies in the Sivaganga South Indian state of Tamil Nadu. It is the native place of prosperous banking and business community called the Chettiyars. In the nineteenth and the twentieth centuries, Chettiyars migrated from their villages in search of fortune in South Asia. They braved the seas and made big fortunes migrating to Malaysia, Singapore and South Africa. Only the men went in search of the fortunes, women, children and parents stayed behind in their native place. Once the riches

Polished granite floors and thick teakwood columns are the hallmark of Chettinad architecture.

were made abroad, it was customary to build massive mansions in their hometown. At each ceremonial function, the families converge upon their ancestral mansions for the celebrations, thereby maintaining a link with their native place. The mansions of Chettinad stand gloriously in the dusty barren landscape of Tamil Nadu. These are lavishly decorated with teak and granite pillars with deep verandas; their halls are decorated with garlanded photographs of the family ancestors. The teak trunks that are used as pillars, doors and ceilings, were sent from the shores of Burma with the help of ocean currents. In those days ocean-going vessels were not big enough to carry them. Once these giant logs were washed ashore, Chettiyars would distinguish their logs by the family initials inscribed on them at the time of throwing them into the sea.

The decoration of the houses in Chettinad is quite eclectic in many ways. Every possible decorative style has been used. Carved doors with Indian and Chinese motifs, ceramic tiles with floral patterns, bold colours were used to paint the columns and the wooden rafters. To smoothen the walls of the rooms, eggshells were ground in the lime plaster. On the outer surface of the homes, stucco figures of divinity were installed for prosperity and well being.

Chettinad is also known for its culinary delicacies — this is evident by the size of the kitchen and the courtyards adjacent to it where these lavish meals are cooked at family get togethers. Its close proximity to Madurai makes it an ideal destination.

Page 80: The typical courtyard of the Chettiyar Mansion in Chettinad region. The stone columns are of granite while the roof and the doors are made from teakwood. *Page 81:* One of the many mansions of the merchants that dot the region of Chettinad.

SOUTH INDIA

Madurai

Madurai, the ancient home of Tamil culture is the seat of the famous temple dedicated to Meenakshi and Sundereshwar. One of the oldest cities in South Asia, Madurai is situated on the banks of the River Vaigai. It has been an important centre of worship and commerce from as far back as the sixth century. Ancient Madurai was also a centre of Tamil culture, famous for its writers, poets and temple builders and was the literary and cultural centre during the last three Sangam periods or literary academics.

Page 84: The view of the gopurams of Meenakshi Temple with the 'Golden Lotus' water tank in the foreground. **Page 85:** Pilgrims in exotic silks add colour to the temple's ambiance. **Below:** There are nine towering gopurams in the Meenakshi Temple, which were constructed during the rule of the Nayaka ruler Thirumalai in the seventeenth century. Some of these temple towers rise to a height of forty-six meters or hundred and fifty feet.

Madurai was the capital of the Pandyan Empire for about a thousand years. It became a major commercial city and trade with Greece, Rome and China flourished. The Pandyan capital fell in the tenth century, when the Cholas gained control over the area. There was a short period in which the Muslim Sultans ruled Madurai. Malik Kafur completely destroyed the city in 1310 plundering and desecrating most of the temples. Subsequently, the Vijayanagar kings captured it in 1364 until the Nayakas asserted their independence. Madurai flourished under the patronage of the Nayakas and the city was rebuilt on the pattern of a lotus centering on the Meenakshi Temple. The Nayakas ruled the city until the eighteenth century when eventually the British took over.

The Meenakshi Temple is an outstanding example of Vijayanagar Temple architecture. The nine massive gopurams of this vast complex are profusely

decorated and some believe that there are as many as 33 million carvings that include a plethora of dancing poses. The temple is dedicated to Meenakshi, Shiva's consort. The temple is named after the daughter of a Pandyan king who, according to a legend, was born with three breasts. At the time of the birth, the king was told that the extra breast would disappear, when she met the man she was supposed to marry, and this happened when she met Lord Shiva on Mount Kailash. Shiva arrived in Madurai, later, in the form of Lord Sundereshwar, and married her.

As Meenakshi is the presiding deity of the temple, the daily ceremonies are first performed in her shrine and unlike other temples, Sundereshwar or Shiva plays a secondary role. Every night the idol of Sundereshwar is taken in silver palanquin to the temple of Meenakshi, the fish-eyed goddess, so that they can spend the night together.

Above, Top: A priest blesses the faithful by smearing holy ash on his forehead. There is a steady flow of pilgrims throughout the day in the temple. People light oil lamps as their sign of devotion in various shrines. **Above, Bottom:** Long pillared hall is supported by the giant monolithic granite columns, while the ceiling is painted with Ganesha (Hindu god of good luck) paintings. **Page 88–89:** Pilgrims praying in front of Meenakshi's shrine, Madurai.

SOUTH INDIA

SOUTH INDIA

The temple has a relatively small entrance and to the left are steps leading down to the sacred tank of the Golden Lotus. To the west of the tank is the pavilion leading to the Meenakshi shrine. The roof of the passage in front of the shrine is painted with numerous Ganesha figures. The passages are full of pilgrims, performing puja or finalizing marriages. The pillars of this pavilion are carved in the form of mythical beasts or yali, a common feature in temples throughout this region. The Meenakshi shrine stands in its own enclosure, surrounded with smaller shrines. The Sundereshwar shrine lies north of the tank within another enclosure and with smaller gopurams on four sides.

The thousand-pillared hall is another main feature of the temple in the northeast corner of the complex. Each column is richly carved and detailed images of Parvati as a huntress playing the veena and Shiva riding a peacock are particularly fascinating. It also houses the art museum, which exhibits brass and stone images and friezes. Although these exhibits are interesting, the five musical pillars carved out of a single stone, definitely steal the show. Each pillar produces a different note on being tapped.

The temples in ancient times were not just limited to worship. Apart from religion, it provided scope for a justice court, a treasure house, and an institution to impart ethical education and fostered various arts including music and dance. The temple is a hive of activity at any given day in the year. More than 15,000 people visit it everyday, with the numbers swelling to 25,000 on Friday, sacred to the goddess Meenakshi.

The Thirumalai Nayaka Palace, a kilometer away from the Meenakshi Temple, was built by the most illustrious of the Nayaka kings and parts of it still survive. Much of the palace was dismantled by Thirumalai's grandson and used for a new

Temple priest praying to the staute of Ganesha marking the start of the night ceremony. **Opposite page:** The sculpture of the goddess of fertility on the columns.

palace at Tiruchirapalli. The original complex had a shrine, an armory, a theater, royal quarters, a harem, and gardens. Mariamman Teppakkulam Tank, few kilometers east of the old city, is the site for Teppam Festival (Float Festival) in the months of January and February.

Women draped in bright silk colours with fresh flowers in their hair participate in a marriage ceremony.

Meenakshi Temple in Madurai is always bustling with energy. Families arrange marriages of their sons and daughters in the corridors along the water tank.

SOUTH INDIA

Above and Right: Thirumalai Nayakar constructed the Thirumalai Nayaka Palace in the Indo-Saracen style in 1636. Swarga Vilasam, the portico, is an arcaded octagon wholly constructed of bricks and mortar supported only by giant, twelve meter tall, round pillars.

Kerala

Kerala, also known as "God's own country" is the lush green land of swaying coconut palms and sandy beaches. According to Hindu mythology, King Parasurama, one of Lord Vishnu's ten incarnations, threw his battle-axe into the sea to atone for his killing of thousands of warriors. The sea forgave him and receded, unveiling a fertile land, today known as Kerala.

Its mountain slopes are rich with plantations of spices, rubber and tea. Kerala boasts of the highest literacy rate in the country and has equally proportioned population of Hindus, Muslims and Christians. The state is renowned for its masked dance dramas such as Kathakali, Theyam and Mohninatyam. The annual temple festivals comprising of hundreds of decorated elephants is also a major draw. It is also reputed for its luxurious backwater cruises and the exciting snake boat races, conducted during the Onam festival. Internationally acclaimed curative ayurvedic treatments based on medicinal plants are other major attractions of this state.

KERALA BACKWATERS

The real charms of Kerala, apart from its palm fringed beaches, are the backwaters, which are a chain of brackish lagoons and lakes lying parallel to the Arabian Sea coast (known as the Malabar Coast). The network includes five large lakes (including Ashtamudi and Vembanad) linked by 1500 km network of canals, both man-made and natural, fed by 38 rivers, and extending almost the entire length of Kerala. The backwaters were formed by the action of waves and shore currents, creating low barrier islands across the mouths of the many rivers flowing down from the Nilgiri mountain range.

Vembanad Lake is the largest of the lakes, covering an area of 200 sq km, and bordered by Alappuzha (Alleppey), Kottayam, and Ernakulam districts. It is designated a wetland of international importance under the Ramsar Convention. Most of the luxury resorts are located on the edge of the Vembanad Lake. The port city of Cochin is located at the lake's outlet to the Arabian Sea.

Above, Top: Lake Periyar situated on the border of Tamilnadu and Kerala in Thekkady region provides a unique insight into the wildlife that exists on its shores. **Above, Bottom:** The sight of the herd of wild elephants is one of many attractions of this beautiful lake. **Opposite page:** Boats are the only way to commute through the backwaters of Kerala. Wide variety of boats of different shapes and sizes are locally made with the materials sourced from this very region.

Page 96: Chinese fishing nets frame dramatically against the setting sun in the jetty of Fort Cochin. These nets were introduced in Kerala by the Chinese traders in the fifteenth century and they can be seen in all the waterways of this idyllic region. ***Page 97:*** Boatman crossing one of the numerous water canals known as backwaters that criss-cross the entire state of Kerala.

The Nilgiris or the blue mountains on the eastern flank of Kerala are scenic with their unending vistas of tea plantations, and on the lower level with spices, coffee and rubber vegetation.

The backwaters form an economical means of transit and a large local trade is carried on by local boats of various sizes. Fishing, rice paddy and coir industries form the economic backbone of this region; these trades rely heavily on inland navigation.

Traditional Kerala house boats known as Kettuvallam ('Kettu' means tied with ropes, and 'vallam' means boat in the local Malayalam language) are the major tourist attraction in the backwaters. A house boat is about 60 to 70 feet in length and has a width of around 15 feet in the middle. The boat is made of wooden planks joined and stitched together using coconut fiber ropes. The outside of the boat is painted using cashew nut oil, which acts as a protective coating. During the time when road and rail transportation was expensive or unavailable, traders used this as a form of main transportation in the inland waterways.

The first houseboats to appear on Vembanad Lake were former rice-barges.

One of the many Catholic churches that dot the backwaters of Kerala. Christians form twenty percent of Kerala's population. *Opposite page:* Numerous resorts have sprung up on the edge of Lake Vembanad that provides a perfect launching pad to explore the interiors of backwaters.

Alleppey town, sandwiched between the backwaters and the coast, is known as the "Venice of the East" as it has a large network of canals that meander through it. The Vallam Kali (the Snake Boat Race) held every year in August, is a major sporting attraction and is held during the harvest festival of Onam in the month of August.

As tourism grew in the region, traditional rice barges (boats that transported rice) were converted to accommodate guests. It is probably one of the most exciting ways to explore the picturesque backwaters and unwind at the same time.

Annual boat race during the Onam festival draws crowds to the shores of backwaters to see their local teams competing in this exciting sport.

SOUTH INDIA

Above and Page 108–109: Approximately hundred oarsmen sit in these narrow long boats, aptly called Snake Boats, and row with great vigour to the beating of the drums.

SOUTH INDIA

An exotic wall painting of Vishnu, the Hindu god, is depicted with his attributes of the conch shell and the disc in the bedroom of the Mattancherry Palace in Cochin. **Opposite page, Top:** The 127 room Padmanabhapuram Palace near Kovalam was the seat of Travancore rulers for more than two hundred years. The long halls with teak wood roof (as seen above) were used in religious and state functions. **Opposite page, Bottom:** The temple within the Padmanabhapuram Palace complex is decorated with monolithic granite columns.

Traditional lamps are placed in designs made by fresh flowers in the courtyards of Kerala homes during the Onam festival. ***Opposite page:*** The temple elephants decorated in finery wait to lead the religious procession in a Kerala village.

Kerala is blessed with some of the finest beaches in the country. Its warm tropical climate adds to this attraction. The beach at Surya Samudra in south Kerala looks stunning with its coconut grooves, white sand and blue sea.

COCHIN

Cochin is the most enchanting city of Kerala. Its natural harbour has attracted voyagers since the Roman times. Its proximity to the tea, rubber, coffee and spices plantations has made it the commercial capital of Kerala. It used to be an important centre of the sea route between Europe and China. The Chinese influence is said to date back to the times of Kublai Khan when they introduced the unique Chinese fishing nets. The presence of the Chinese must have been quite prominent which is reflected in the vast quantities of Chinese pickle jars and antiques that are available. The culture of the city is very cosmopolitan, with influences of the Chinese, Jews, Arabs, Portuguese, Dutch and the English contributing to it. This flavour is still evident in the Fort Cochin area, which houses an incredible number of colonial buildings. Fortunately, it has been spared from the building frenzy, which can be seen in the Ernakulam region of the city.

Chinese fishing net. *Opposite page:* A fishing trawler returns to Cochin. The old city in the background is a charming place to explore quaint streets lined with colonial villas.

SOUTH INDIA

The eventful history of this city began when the major cyclonic flood of 1341 opened the estuary at Cochin, till then a land-locked region, turning it into one of the finest natural harbours in the world. As a result, voyagers looked forward to visit this first truly international port of the Indian peninsula. Vasco da Gamma, who discovered the sea route to India, lived in Fort Cochin. The Dutch ousted the Portuguese in 1633 and finally, the British took control of Princess of the Arabian Sea, as the sailors lovingly called the city, from the Dutch in 1795.

Chinese fishing nets along the promenade in the Fort Cochin are the most photogenic landmarks of Cochin. The nets are erected on teakwood and bamboo poles and their working is controlled by huge stones tied to the other end to provide a counterbalance. These nets were brought here in the fourteenth century by the Chinese traders from the Court of Kublai Khan. During the high tide, the area is buzzing with activity. The seafood shops sell their fresh catch, which you can buy and get cooked in one of the numerous stalls close by.

The Santa Cruz Basilica was built originally by the Portuguese and elevated to a Cathedral by Pope Paul IV in 1558. Luckily, it was spared by the Dutch conquerors who destroyed many other Catholic buildings. Later, the British demolished the structure and Bishop Dom Gomez Vereira commissioned a new building in 1887. Consecrated in 1905, Santa Cruz was proclaimed a Basilica by the Pope John Paul II in 1984.

Many of the old colonial buildings in the Fort area have been lovingly restored retaining the colonial flavour, and are opened as hotels. A few minutes ride from Fort Cochin is the Mattencherry or the Jew Town. It is famous for its Dutch Palace, built by the Portuguese for the Hindu king in order to gain trading rights. Later, the Dutch restored it. It is an interesting museum with fabulous frescoes based on the Hindu epics painted on the walls. The highlight of this

Above, Top: Jew Town in Mattancherry boasts of the oldest Synagogue east of Israel. Its floor is decorated by hand-made Chinese tiles imported from Canton by a wealthy spice merchant. Jewish community dominated the spice trade till recently and lived in complete harmony with the local population.
Above, Bottom: St. Francis Church is the oldest church in India dating back to 1546 AD. **Opposite page:** The Jew Town is becoming a treasure trove for people looking for antiques, which are salvaged from the pulled down mansions.

section is the Synagogue, the oldest in Asia. It enjoys a colourful ambiance with painted Chinese blue tiles on the floor and dozens of colourful chandeliers hanging from the ceiling. The Synagogue Street houses the few remaining families of Cochin Jews. It was once a dynamic community who excelled as the middlemen between the Europeans and the local population. The area is fast becoming a haven for antique dealers. Nearby, some old warehouses still deal with traditional spices. The strong aroma emanating from them, will guide you to their door.

Portuguese Franciscan Friars built St. Francis Church in 1503. It is one of India's oldest churches. Initially, it was built as a wooden structure; later the Portuguese replaced it with a permanent stone building. During the Portuguese rule, it remained a Roman Catholic Church right up to the seventeenth century. Later, the Dutch converted it into a reformist church (1664 – 1804) and finally, the British made it into an Anglican church from 1804. Today, it is known by the name of the Church of South India.

Another important fact about the church is that Vasco da Gamma, who died in 1524, was buried here before his mortal remains were taken to Portugal fourteen years later. The church has an airy feeling about it with big windows and huge punkhas, old style fans operated with the help of a rope by a person sitting outside the room.

Today Cochin is a rich trade centre, a major military base, a busy port, a great shipbuilding centre and a centre for Christianity. It also has the swankiest airport of India. The wealth of the city and its surrounding area can be gauged by the numerous jewellery shops that can be seen everywhere. No trip to Cochin is complete unless you cruise down the backwaters of Allepey and drive up to Tekkady, probably the most scenic route of India. If you have time and the inclination, then the beaches of Kovalam are a good place to unwind with Kerela's famed Ayurvedic massages.

Above, Top: Spices of all colours and taste are on sale in Fort Cochin. ***Above, Bottom:*** Young dancer dressed as a tiger cub during the celebration of the Onam festival. ***Opposite page, Top:*** A dancer putting on the traditional dress for a performance of the local dance drama called Kathakali. This dance form maintains strict traditions even after its thousand years of history. ***Opposite page, Bottom :*** Coffee shops abound every street corner in Kerala. Local men dressed in traditional sarong called lungi crowd such establishments. ***Pages 122–123:*** Nature's drama unfolds every day at sunset over Lake Vembanad.

SOUTH INDIA

BANGALORE

Bangalore is the fifth largest metro in India with its population close to six million. Great Kannada warrior, Kempe Gowda laid the foundation of the city in 1537, declaring it as a province of the Vijayanagar Empire. After the fall of the Vijayanagar Empire, it was captured by the Marathas who eventually sold Bangalore to Chikkadevaraja Wodeyar, the Maharaja of Mysore for a princely sum of Rs 300,000 in the year 1687.

Later, after the passing away of Krishnaraja Wodeyar II in 1759, Hyder Ali, Commander-in-Chief of Mysore forces, proclaimed himself as the ruler of Mysore. After Hyder Ali's death, his son Tipu Sultan, also known as the Tiger of Mysore, ruled the region. In 1799, the British East India Company's forces defeated Tipu Sultan and returned the control of Bangalore to the Wodeyars. However, they retained the control of the cantonment area of the city. In 1831, the capital of Mysore state was transferred from Mysore to Bangalore. Later, Bangalore's link to the port city of Madras via rail led to its rapid growth.

In 1906, Bangalore became the first city in India to have electricity, powered by the hydroelectric plant situated in Shivanasamudra. Bangalore's reputation as the Garden City of India began in 1927 with the Silver Jubilee celebrations of the rule of Krishnaraja Wodeyar IV. Several projects such as the construction of parks, public buildings and hospitals were instituted to beautify the city. After Indian independence in August 1947, Bangalore remained in the new Mysore State of which the Maharaja of Mysore was the Rajpramukh or the Governor.

Bangalore is going through an unprecedented economic boom in the last ten years. Its businesses are attracting young professionals, not only from India but all over the world. Because of the high disposable incomes of the young workforce, there has been mushrooming of pubs, fancy restaurants and the entertainment industry with international rock bands performing here often.

Much of the credit for this transformation of Bangalore goes to industrial visionaries like Sir Mirza Ismail and Sir Mokshagundam Visvesvaraya who in the 1940s played a pivotal role in the development of Bangalore's strong manufacturing and industrial growth. The rapid growth of Information Technology has made Bangalore the software capital of the country. Many MNCs have established base here. But this has put pressure on its poor infrastructure and led to tensions between IT professionals and the laid back bureaucracy, which has its electoral base in rural Karnataka.

Biotechnology is a rapidly expanding field in the city. Bangalore accounts for 47% of the biotechnology companies in India. Aeronautics and scientific research are other major areas responsible for the diversified growth of the city.

Bangalore is known as the Garden City of India because of its climate, greenery and the presence of many public parks, including the Lal Bagh and Cubbon Park. Dussehra, a traditional celebratory hallmark of the old Kingdom of Mysore, is another important festival.

Bangalore has a number of elite clubs, like the Bangalore Golf Club, Bowring Institute and the exclusive Bangalore Club, which counts among its previous members — Winston Churchill and the Maharaja of Mysore.

The city is a perfect launch pad for excursions deeper into Karnataka.

Vidhan Saudha is the grey granite neo-Dravidian style parliament building of Karnataka. **Opposite page, Top:** Lal Bagh or the botanical gardens were commissioned in the eighteenth century by Hyder Ali. There are more than eighteen hundred species of plants and trees of ornamental and medicinal variety. **Opposite page, Bottom:** An old colonial building that has somehow survived the unplanned commercialization.

SOUTH INDIA

Above and Right: The Bangalore Palace is decorated with choicest furniture and artifacts sourced from European cities at the turn of the century.

Page 124: The Maharaja of Mysore built himself a new palace on the lines of Windsor Castle in the colonial city of Bangalore. *Page 125:* Vidhan Saudha.

SOUTH INDIA 129

MYSORE

Mysore, with the Palace of the Maharaja, continues to be the centre of cultural life in Karnataka. Henry Irwin built the palace in an Indo-Saracenic style of grand proportions in 1912 for Maharaja Krishnaraja Wodeyar IV. It is one of the largest palaces in the country, beautifully restored and maintained. The palace hosts the world famous Dussehra festival every year in the month of October. The former princely state of Mysore is also famous for its sandalwood and jasmine gardens.

Maharaja Krishnaraja Wodeyar IV commissioned two-storeyed Lalit Mahal Palace in 1921 as guest house to house visiting dignitaries. This palace which is set in the middle of sprawling terraced gardens was built the British architect E.W. Fritchley in the Renaissance style.

Page 130–131: Mysore Palace was built in the nineteenth century using Indo-Saracenic style by Henry Irwin for the Wodeyars, the rulers of Mysore. It is a beautiful amalgamation of Hindu, Islamic, Rajput and colonial traditions. On weekends, it is lit up by 27000 electric bulbs and truly is a sight straight from the pages of fairy tales.

SOUTH INDIA

The portrait of Maharaja Krishnaraja Wodeyar IV was painted by Raja Ravi Verma. ***Opposite page:*** The grand staircase at the entrance of Lalit Mahal Palace leads to the suites on the first floor.

The majestic Elephant Gate is the main entrance to the centre of the palace and bears the Mysore royal symbol of the double-headed eagle, now the state emblem. The elaborately decorated, gem-studded elephant seat or the howda, made of 84-kg gold is of particular interest and is used to carry the deity during the Dussehra festival.

The octagonal Kalyan Mandapa, the royal wedding hall, south of the courtyard has a beautiful stained glass ceiling and magnificently detailed oil paintings illustrating the great Mysore Dussehra festival of 1930. This opulent hall still houses some of the finest Belgian crystal, silver furniture and Bohemian chandeliers.

An Italian marble staircase leads to the magnificent Darbar hall, a grand colonnaded hall with lavishly framed paintings by famous Indian artists including Raja Ravi Varma. The massive hall affords views across the parade ground and gardens to Chamundi Hills. The Maharaja gave audience from here seated on a throne made from 280 kgs of solid Karnatakan gold. The jewel encrusted golden throne with its ornate steps was originally made of fig wood decorated with

ivory before it was embellished with gold, silver and jewels.

The passage through the beautifully inlaid wood and ivory door of the Ganesh Temple leads to the Ambavilas, the private audience hall. This extraordinary decorated hall features beautiful stained glass and gold leaf paintings.

Three richly decorated doors lead into the Diwan-i-khas. The central silver door depicts Vishnu's ten incarnations and the eight Dikpalas or the directional guardians.

The Jaganmohan Palace, a little further west of the Maharaja's palace was used as a royal residence until Krishnaraja Wodeyar IV turned it into a picture gallery and museum in 1915. The ground floor displays costumes, musical instruments and numerous portraits and photographs. A series of nineteenth and twentieth century paintings dominate the first floor. The work of Raja Ravi Varma is particularly interesting, because he was the first to introduce modern techniques in Indian art.

Devraja market is a tourist's delight. It has numerous

stalls selling fruits, vegetables, colourful kumkum used by Hindu women in the parting of their hair to announce their marital status, and jasmine flowers being sold by the kilos. Incense and spice shops abound this colourful market place.

The Lalit Mahal Palace, situated 11 kms from Mysore city, is set in the middle of sprawling terraced gardens. Maharaja Krishnaraja Wodeyar IV commissioned this two-storeyed palace in 1921. This palace was built by the architect E.W. Fritchley in the Renaissance style.

The central hall is decorated with life size portraits of the royalty of Mysore, lithographs portraying Tipu Sultan's battles with the British line the walls of the corridors. The viceroy room, banquet hall, dancing floor and an Italian marble staircase have been carefully maintained.

Chamundi Hill, immediately to the southeast of the city, is topped with a temple of Durga, Chamundeshwari, the chosen deity of the Mysore Rajas. This twelfth century temple features a Chamundi figure of solid gold. Outside in the courtyard, stands a fearsome statue of the demon buffalo, Mahishasur. A little further downhill is a magnificent five-meter Nandi, Shiva's bull, which dates back to the seventeenth century.

Giant Nandi, Shiva's bull at the base of Mysore Hills. **Opposite page:** Tomb of Hyder Ali and Tipu Sultan in Srirangapatnam.

SOUTH INDIA

Page 136–137: Flower Market of Mysore is an interesting place to visit to see the variety of products that are sold. The delicious aroma of spices, incenses and jasmine flowers that are sold by the kilos, lingers with you for the rest of the day.

Somnathpur, Halebid & Belur

Hoysalas, who were the feudal lords of the Chalukyas of Kalyani, became independent in the eleventh century and founded a new dynasty with their name. They constructed magnificent temples in Halebid, Belur and Somnathpur. Hoysala temples stand out more for their sculptural workmanship rather than architectural achievements. The three temples — Halebid, Belur and Somnathpur, situated in the state of Karnataka, are considered the gems of Hoysala architecture.

A group of local women with traditional flower garlands in their hair on a visit to the Keshava Temple of Somnathpur.

The hallmarks of these temples are the star-shaped platforms with wide circumambulatory space on which they are built.

The Hoysala Temple consists of a vimana, connected by a short antrala to a closed navaranga which is preceded by mandapa. The temple walls have many triangular folds, which gave artists more surface area to exhibit their skills on, and also the play of light and shadow is thus more amplified. The carvings are so fine and delicate that at the first glance, they appear to have been done on sandalwood. Nowhere in India are temples so intricately carved as are these three. Every square inch of their walls is lavishly decorated with figures of gods and goddesses, along with an elaborate foliage design on each divinity.

The remaining surface is covered with the Hindu epics of Mahabharata and Ramayana. Armies of soldiers and animals cover the lower part of the temple. Another noteworthy feature is the lathe-turned columns, which adorn the temple hall and circumventor passages.

The temples were built between the twelfth and thirteenth century by the Hoysala dynasty. The origin of the name of the dynasty is a heroic legend, in which Sala, the founder of the dynasty, kills a tiger single-handedly. This story can be seen translated into a sculpture of Sala fighting the tiger at all temples. Unlike other temples of India that are made out of granite or sandstone, Hoysala temples are made with softer dark grey-green chlorite schist, which is conducive to fine carving and hardens with the passage of time. No wonder that details of the sculptures are simply exquisite. So minute are the carvings, that even the details such as jewellery worn by the divinities, the rings on the fingers, the nails, or as in one statue, the bracelet of the dancer is free to rotate on her wrist. After the destruction of Halebid at the hands of the Muslims, a new capital, Belur, was established close by.

Page 140: Somnathpur is about an hour's drive in the lush green countryside of Mysore. The Keshava Temple located in this sleepy village is the finest example of Hoysala architecture. The interior hall of the temple is decorated with monolithic 'lathe turned pillars', a classical feature of Hoysala temples.
Page 141: Details of bas-relief in Belur Temple.

Remarkable sculpture of Vishnu seated on the bed of coiled serpents called the Nagas. The entire surface of the temple is decorated with sculptured details of mythological stories and foliage design. ***Opposite page:*** The hallmark of the Hoysala temples is the star-shaped platform on which they are constructed. ***Pages 146–147:*** The temple walls of the Keshava Temple are decorated with exquisite friezes of gods and goddesses of the Hindu pantheon. The foliage decoration on top of the statues is the hallmark of Hoysala craftsmanship. The soft stone made it possible for artists to carve out fine details in the statues where the rings, earrings and bracelets are well-defined.

SOMNATHPUR

Somnathpur is smallest of the three Hoysala temples. It was built by Somnatha, an official under the Hoysala King Narasimha III (1254-1291). It is an excellent introduction to Hoysala art and architecture. Although the carvings are not as elaborate as its predecessors at Halebid and Belur, it makes up for it by surviving in its original form. It stands on a raised star-shaped platform in the centre of a rectangular courtyard, having sixty-four cells and a passage supported with lathe-turned columns. The temple is unique with its three shikhars (trikutachala), three garbha grihas and three antralas joined to a common navaranga. The ceiling inside the temple is remarkable, with the keystone of the sixteen domes sculpted as a banana flower in different stages of flowering. Outside, the walls of the temple have been profusely decorated with friezes of gods and goddesses, Puranic and epic scenes. The majority of the sculptures are attributed to the artist Mallithamma. The inscriptions in the temple give details of construction and mention the grants given for the upkeep of the temple. There is a back staircase to the roof from where one can view the surroundings. This bird's eye view never fails to impress the viewer, with its unique star-shaped composition of this temple.

HALEBID

Halebid, the ancient Hoysala capital, houses the ornate Hoysalesvara Temple that dates back to the twelfth century. It was built by Ketamalla, a minister of Vishnuvardhana, the Hoysala ruler, and is dedicated to Lord Shiva. He also built the Belur Temple and the Mahabaleshwar Temple at Chamundi Hills near Mysore. The temple surpasses both of them in architecture and refinement of sculptures.

Halebid's decline set in, when it was sacked by the Muslim general Malik Kafur in the early fourteenth century. After the attack, the city never regained its former glory. Today, only a handful tourists come to see the beauty of this secluded Hoysala masterpiece. The twin temples are connected by a passage on the inside, with a dance hall or mandapa on either end. There is a statue of a giant Nandi, vehicle of Lord Shiva, facing the temple. Elaborate carvings decorate the entire face of the temple.

The Hoysalesvara Temple in Halebid, dating back to 1121 AD, is astounding for its wealth of sculptural details. The walls of the temple are covered with an endless variety of depictions from Hindu mythology, animals, birds and apsaras or dancing figures. It was sacked by the armies of Malik Kafur in the early 14th century, after which it fell into a state of disrepair and neglect. ***Opposite page:*** Shiva with his consort Parvati. ***Page 150:*** Ravana lifting Mount Kailasha to extort boon from Shiva. The mountain abode of Shiva is carved with fine details of forest and animal life. Shiva and Parvati are seated on top. ***Page 151:*** Shiva performing his cosmic dance.

SOUTH INDIA

BELUR

Belur's religious importance can be understood as it is compared to the holy city of Varanasi by the local people, who proudly refer to it as Dakshin (the southern) Varanasi. It is said that King Vishnuvardhana, after defeating the mighty Cholas of South built the temple of Chennakeshava. The temple is dedicated to Vijaya Narain, an incarnation of Vishnu, and was built in 1117. According to inscriptions, the temple was built to commemorate his conversion from Jainism to Vaishnavism.

The surface of the temple is filled with friezes of Vishnu, stories of Puranas and other Hindu epics, carved out in minutest details. Celestial beauties, Mandakinis, are carved into brackets supporting the overhanging eaves.

These sculptures epitomizing feminine grace are the finest example of the Hoysala art. The lady dressing herself, the lady with the mirror, the lady with the parrot and the huntress are noteworthy for their feminine grace and beauty. Inside the temple, one of the columns was adorned with a map of the temple and this giant column was freely rotating on its axis!! The carvings on it can still be seen, but erosion has now jammed its free movement. The temple is a veritable museum of sculpture and intricate floral carving.

Among the Hoysala temples, Chennakeshava is the only living one. The other two, Halebid and Somnathpur, do not have ritual service. For this reason the temple is buzzing with life and religious ceremonies. In the large courtyard, one can see subsidiary shrines and temple chariots in the shapes of various animals adding colour to the temple. The Vijayanagar kings contributed the entrance tower on the east side at a later date.

The drum player; note the intricately carved drum strings and the left hand going into them. ***Opposite page:*** The Chennakeshava Temple in Belur is the temple dedicated to Lord Chennakeshava (meaning handsome Vishnu) and is one of the finest examples of Hoysala architecture. It was built by king Vishnuvardhana in 1117 AD and is said to have taken more than 103 years to complete. The façade of the temple is filled with intricate sculptures and friezes of elephants, lions, horses, episodes from the Indian mythological epics, and sensuous dancers.

A religious procession been taken out of the Chennakeshava Temple. **Page 156–157:** Every square inch of the temple façade is richly adorned by intricate carvings. At the base are the animal figures, while divinities and heavenly dancers occupy the top portion of the temple.

SOUTH INDIA 155

Opposite page: Shravanabelagola is one of the most revered Jain pilgrim centers of the country. The eighteen metres tall serene monolithic statue representing Bahubali in deep meditation. The anthills near his legs and creepers entwining his legs and arms show his complete withdrawal from the illusionary world. **Above:** A pilgrim touching the feet of Bahubali as a mark of obedience.

Shravanabelagola

The eighteen-metre-high monolithic statue of Bahubali, carved out of living rock atop the Udaygiri Mountain, is the chief attraction at Shravanabelagola. It is an important pilgrimage centre in South India for Jains.

Badami, Aihole & Pattadakal

Situated along the Malprabha River in the lower Deccan region, these ancient sites of the Chalukyan capital date between the sixth and the eighth century. During the reigns of Pulukesin I and his son Pulukesin II, of the Chalukya dynasty, there seems to have been a flow of creative energy, not witnessed ever before in history. More than two hundred temples were built during this period. But only some fifty-odd survived the ravages of time. They represent Hindu, Jain and Buddhist faiths. The temples showcase the transition of rock-cut cave temples to that of free standing ones. It is the birthplace of temple architecture of India. Dravidian, Jain, Buddhist, Hoysala and Nagar styles can be seen in their emerging stages, which finally culminated in the mighty Kailasha Temple of Ellora.

BADAMI

Southwest of Pattadakal, on the Malprabha River is Badami. In the earlier texts, it is mentioned as Vatapi. It was the capital of the legendary Puru Pulukesin II of the Chalukya dynasty from 543-757 AD. Later, Pallavas occupied it in the mid-seventh century, until, finally the Rashtrakutas took over. This sleepy town is attractively situated at the mouth of a narrow valley between two rocky hills and nestling in its fold is the picturesque Bhoothnath Lake. This idyllic setting is punctuated with ruins of the fabulous golden coloured sandstone temples. The Early Chalukyas chose the finely grained, horizontally stratified cliff face which facilitated excavation of large cave temples, execution of fine sculptures and intricate carvings in them. There are four such cave temples; three are Brahmanical and fourth is Jain.

Cave number three is the oldest and largest. It is dedicated to Vishnu and was excavated in 578 AD by king Mangalesha. The other cave is dedicated to Shiva and smaller one dedicated to Vishnu. The cave temples consist of a rectangular-pillared verandah, a square-pillared hall and a square-shrine cell in the rear. The verandahs are adorned with elaborately carved columns and the walls are decorated with life-size friezes of Hindu epics. The fourth cave temple is dedicated to Jain tirthankar, Parshwanatha. It is right on the top of the three caves and was built about a century later. It also offers a stunning view of the valley, especially that of the Bhoothnath Temple on the edge of the lake whose water is said to have healing properties.

Spectacular view of the Bhoothnath Lake of Badami from South Fort. The dramatic red sandstone mountains form a perfect backdrop with ruins of North Fort on top.

SOUTH INDIA

Page 160: A beautiful sculpture of Shiva along with his vehicle, the Nandi bull, in the circumventory passage of the Durga Temple, Aihole.
Page 161: Sculpture of Vishnu on the ceiling of the cave temple in South Fort, Badami.

Cave no. 4 in South Fort, Badami is dedicated to Jain religion and dates to mid-seventh century. The statue of Parshwanatha can be seen in the far end, while the columns too have engravings of Jain prophets.

Cave no. 3, South Fort, Badami dates back to mid-sixth century and is dedicated to Vishnu. The panel above shows Vishnu in Narasimha avatar (half man and half lion). Amorous couples adorn the bracket of the column on the right.

AIHOLE

Aihole, inscriptions refer to it as Aryapura, occupies a unique place in the history of the temple architecture of India. It was the experimental ground for the Early Chalukya kings (450-750 AD) to build structural temples from mid-fifth century onwards.

Within the ancient fortification, there are fifty temples and the same amount exists outside. Most of the temples were originally dedicated to Vishnu but later converted to a worship of the Shiva cult.

The earlier temples are of pavilion type with a slightly sloping roof. The first phase of early Chalukya Temple architecture ended with the construction of Meguti Temple, which incidentally is the first structural temple (634 AD) in India. An inscription on the temple mentions the great poet, Kalidas, in the court of Chandra Gupta Maurya.

Further experimentations in giving a cognate shape to the temple roof by adding towers, resulted in evolving three distinctive styles namely: Dravida, Nagra and Kadamba-Nagra, of which latter is a more evolved form of Dravida style and is evident in Badami and Pattadakal temples.

The Durga Temple is unique in conception on account of its apsidal plan but with non-apsidal curvilinear sikhara. Its name is misleading as it is dedicated to the sun god Surya and not to goddess Durga. It is named so as it was within the walls of a fort (Durg). The structural art of these temples is full of vigour. There are also some Jain temples belonging to the later Rashtrakuta period.

An exquisitely carved pillar in Durga Temple. *Opposite page:* Narayana Temple at Aihole. *Pages 168–169:* The view of Aihole as seen from the roof of Gaudargudi Temple. In the foreground are the primitive temples of Cakra group and in the background is the highly evolved Durga Temple with an apsidal end and a circumventory passage.

SOUTH INDIA

PATTADAKAL

Pattadakal was the second strong hold of the early Chalukyas and served as the capital between the seventh and the eighth century. It is located on the banks of the river Malaprabha, not very far from Aihole. The architecture shows the continuation of the evolution of both Dravidian style and the Nagra style temples from Aihole. The temples here are dedicated to Shiva, Hindu lord of destruction. The sculptures on the temples ornately depict the societal life of the early Chalukyas.

The notable temples in Pattadakal are Virupaksha Temple, Mallikarjuna Temple and Sangameshvara Temple, which shows the climax of evolution of the early Dravidian vimana style started at Aihole.

A ruined Shiva Temple is survived by black granite Nandi bull, Pattadakal. **Opposite page:** Nandi Mandapa in front of the Virupaksha Temple at Pattadakal.

Page 170: Ravana Phadi Cave Temple at Aihole. ***Page 171, Top:*** The sloping roof of Ladh Khan Temple in Aihole has two-tiered sloping roof, that replicates wooden construction, but with the use of stone logs. Aihole was the capital of Chalukyan rulers between the fourth and the sixth century. The temples here are unique as they show the transition of Hindu temple architecture from proto types to decorative ones. ***Page 171, Bottom:*** Frieze of dancing Shiva at the entrance of Ravana Phadi Cave Temple at Aihole.

Above & Opposite page: Virupaksha Temple at Pattadakal was built in the eighth century on the lines of the Kailasanatha Temple of Kanchipuram. The temple is built on an elevated plinth with walls decorated with carved deities of the Hindu pantheon. It is the finest example of early temple architecture in India.

Hampi

If there were a competition among the most exotic sights of India, Hampi would be a serious contender for the first place. This city of victory, Vijayanagar, is set in a surreal landscape of large smooth boulders that have miraculously hung in balance through centuries.

A masterpiece of Vijayanagar artisans is the stone ratha or chariot in Vitthala Temple. It is unique in its execution as the entire wooden chariot with intricate details is replicated in stone. **Opposite page, Top:** Elegantly carved monolithic stone columns in the ardhamandapa of Vitthala Temple. This hall was used for marriage celebrations. **Opposite page, Bottom:** A sculpted black granite monolithic pillar in the Hazar Rama Temple. **Page 176:** The panoramic view of Virupaksha Temple as seen from the Hemkunt Hill at dawn. The temple is situated in the picturesque landscape of Hampi and lies south to Tungabhadra River which can be seen in the background. **Page 177:** A group of young girls in colourful attire on a sight seeing trip of Hampi.

In this awesome theater of nature are the ruins of Vijayanagar, spread in the area of twenty-six square kilometers. The history of the site gains importance with the Vijayanagar dynasty in the fourteenth century. Two brothers, Harihara and Bukka, laid the foundation of the empire in 1336. Later, Bukka's son Harihara II not only consolidated the empire but also brought Sri Lanka and Burma under Vijayanagar's control. Later in the early sixteenth century, Vijayanagar entered its golden era under the rule of Krishnadevaraya. He had visitors from Persia, Italy and Portugal at his court. All of them speak of the splendours of his empire and the affluence of its citizens. It is not hard to imagine the splendour of Hampi by the magnitude of ruins that still abound the site.

He erected some of the most important temples of the city. The giant monolithic image of Laxmi Narasimha (Vishnu's avatar) is attributed to him.

The monkey kings, Vali and Sugriva of the Hindu epic Ramayana, are believed to have ruled close to Hampi. Sugriva and Hanuman were driven out of the kingdom by Vali. Taking pity on the plight of the monkey chiefs, Rama eliminated Vali and restored the kingdom to Sugriva.

A huge mound of ash in the adjacent village is believed to be the cremation site of Vali. Rama lived in Hampi while the monkey chief Hanuman went to look for Sita in Lanka, the capital of the demon king, Ravana.

The most imposing religious building of Hampi is the Vitthala Temple. It is situated on the southern bank of the Tungabhadra River and was built during the reign of Devaraya II in the mid-fifteenth century. It is located in a rectangular enclosure within which stand the main temple, kalyan mandapa and utsav mandapa. Mahamandapa is decorated with sculptured friezes of horses and warriors. Of the fifty-six columns, the ones outside are decorated with Narasimha figures

Pages 178–179: Magic of Hampi unfolds at sunrise when numerous ruins spring to life from the shadows of the dark night. The ruins of this great city of Vijayanagar are strewn over twenty-six square kilometers in a surreal landscape of rounded boulders and lush green coconut grooves.

SOUTH INDIA

while female dancers and musicians decorate the ones inside. The ceiling is carved with beautiful lotus motifs. The temple shows the zenith of Vijayanagar art and architecture.

A marvel of Vijayanagar art is the stone chariot, which is located in front of the main shrine, which is dedicated to Garuda, the vehicle of Vishnu, the mythological half-bird-half-man. It is the precise replica of the wooden temple chariot, but here it has been translated into stone. The minutest details have been incorporated into the carving and designed so much so that once it was possible to rotate the stone wheels of this magnificent Ratha. Two elephants are carved in the front appear to be ready to pull the Ratha to any distance.

Southwest of the temple, are the ruins of the King's balance. On auspicious days, the king was weighed against gold and precious stones that were later distributed among the citizens. To see the sunrise over the Virupaksha Temple from the Hemkunt Hill is an unforgettable experience. Hampi is one of those places in the world where you feel that any amount of time spent there is not enough.

The Lotus Mahal in the royal enclosure at Hampi was used as a summer palace to escape from oppressing heat of the region.

SOUTH INDIA

Elephant Stables is the majestic structure of royal center. The top is lined with alternating ribbed cupolas and conical domes with corresponding eleven chambers, many of which are linked with arched door from the inside. The elephants housed here were the best in the kingdom and were used in royal processions.

Door of a secondary shrine at Virupaksha Temple. **Opposite page:** Temple musician welcomes the pilgrims by blowing his traditional trumpet.

Hyderabad

Andhra Pradesh is the state where predominantly Telugu speaking population resides. It can be called the geographical gateway to South India as the Deccan Plateau, which demarcates the southern peninsula, originates in this state. The plateau acted as a natural defense, sheltering Andhra Pradesh from the waves of invasion that affected North India. This allowed the Muslim-ruled state of Hyderabad to develop a distinctive culture during the Qutb Shahi dynasty and later, the Asaf Jahi dynasty popular by the name of the Nizams.

A tomb of Qutb Shahi ruler. **Opposite page:** Charminar or four minarets, which were possibly made to honor the first four caliphs of Islam. The actual mosque occupies the top floor of the four-storey structure.

Today, Hyderabad is the capital city of the state and is the fifth largest metro of India, with a population close to 10 million inhabitants. The city is known for its rich history, culture and architecture, which gives it a unique character.

Hyderabad rose into prominence during the 16th and early 17th centuries, when the power of ruling Qutb Shahi dynasty reached its zenith. The economy of the city flourished as it became the center of diamonds, pearls, steel, arms, and textile trade and became one of the leading markets in the world. Qutb Shahi sultans were fond of literature and were great builders and gave the city its distinct Indo-Persian architecture and culture. In the 16th century, the city grew to accommodate the surplus population of Golconda and eventually became the capital.

The sixth Mughal ruler, Aurangzeb, focused his attention on the Deccan region, making it a base to consolidate South India. He laid siege on impregnable fort of Golconda in 1687 for nine months. Finally, the gates were opened by a saboteur. Sultan Abul Hassan Tana Shah, the seventh king of the dynasty, was taken prisoner and Aurangzeb ruled Deccan for four decades.

After Aurangzeb's demise in 1707, the decline of the Mughal Empire set in. The Mughal-appointed governors of Hyderabad declared their independence from the waning Mughal Empire. In 1724, Asaf Jah I, the governor appointed by the Mughals, defeated his rival to establish control over Hyderabad. Thus began the Asaf Jahi dynasty, which would rule Hyderabad until a year after India's independence.

Asaf Jah's successors were bestowed upon the title of 'Nizams of Hyderabad'. Osman Ali Khan, Asaf Jah VII was the most illustrious rulers of the princely state of Hyderabad. He ruled Hyderabad between 1911 and 1948, until it was invaded and annexed by India. The British called him "His Exalted Highness, The Nizam of Hyderabad".

Nizam Palace, now converted to house supreme judicial body of Andhra Pradesh.

Page 186: Hyderabad was ruled by the Qutb Shahi dynasty, which prided in adopting Persian culture and religion, thus giving its vast Muslim population distinctively rich culture and cuisine. The market places in the old city conserve the ambiance of the medieval ages and sell vast array of merchandise including its famous pearls. ***Page 187:*** Local woman dressed in a traditional Muslim dress known locally as 'burka'.

The rule of the seventh Nizam was the golden period of Hyderabad, both culturally and economically. Hyderabad became the formal capital of the kingdom and Golconda, which was all but abandoned. Huge reservoirs were built to protect the population against famines. From a bankrupt state that was the size of the United Kingdom, the seventh Nizam, Mir Osman Ali Khan, made it into the wealthiest state in the sub-continent. He was considered the world's richest man and was featured in the cover story of Time magazine (Feb. 22, 1937). Hyderabad was considered the "senior-most" princely-state within the elaborate protocols of the Raj. Its ruler, the Nizam, was accorded a 21-gun salute. The state had its own currency, mine, railways, and postal system. There was no income tax. The Nizam was famous for his patronage of learning institutions and hospitals.

Some of his idiosyncrasies included collection of sports cars and pornography. He was known to use the 400 carat Jacob Diamond casually as a paperweight. He built the magnificent Hyderabad House in Delhi, now used for diplomatic meetings by the Government of India.

Charminar meaning "Four Towers" or "Mosque of the Four Minarets" is the most important landmark of the city of Hyderabad. Muhammad Quli Qutb Shah built the monument in 1591 when he shifted his capital from Golconda. He supposedly prayed and promised to the almighty that if the plague that had spread in the city ended, then he would build a mosque in the heart of his capital. The mosque became popularly known as Charminar because of its four minarets, which possibly honor the first four khalifs of Islam. The actual mosque occupies the top floor of the four-storey structure. This unique mosque is a fine example of the Indo-Islamic style architecture. Charminar overlooks another beautiful mosque called Mecca Masjid. A thriving market,

Intricate stucco decoration on the minaret of the tomb. **Opposite page:** The burial grounds of the Quli Qutb Shah rulers are located on the outskirts of the city of Hyderabad. Here one can see the place where the body is laid to be purified before the burial.

which still retains the medieval charm, lies around the adjacent streets. The crowded colourful bazaars here sell vast array of traditional crafts ranging from famous Hyderabad pearls to glass bangles. The area is also known for local eateries selling the famous rice dish, the Hyderabadi Biryani.

Golconda, situated west of Hyderabad, is the ruined capital of ancient Hyderabad state. After the collapse of the Bahmani Sultanate, Golconda rose to prominence as the seat of the Qutb Shahi dynasty around the sixteenth century. The original mud fort was expanded by the first three Qutb Shahi kings into a massive fort of granite. It remained the capital of the Qutb Shahi dynasty for nearly a century, when the capital was shifted to Hyderabad. Later, the fort was further extended and a ten-kilometer wall was constructed to enclose the city with. The state became a focal point for Shia Islam in India.

Golconda was the only known source of diamonds in the world before they were mined in South Africa. Magnificent diamonds such as Darya-e Nur, Nur-Ul-Ain Diamond, Koh-i-noor, Hope Diamond and the Regent Diamond, all came from the Golconda mines.

Qutb Shahi Tombs are the resting place of Qutb Shahi sultans and are situated north of the Golconda Fort. These structures are decorated with refined delicate stucco-work on the minarets and the arches.

Chowmahalla Palace and the Falaknuma Palace are other important monuments to be visited in Hyderabad.

Today, Hyderabad has evolved into a major center of information technology, with a suburb, called Cyberabad, solely dedicated to it. It is also a hub for the pharmaceutical, biotechnology and aviation industries. World-renowned management institutes are located here, making Hyderabad an important destination for higher learning.

GOA

Each year, Goa lures thousands of international and domestic tourists to its renowned beaches. The laid-back and relaxed charm of Goa is accentuated with white-washed churches nestled among the coconut grooves, its lush green paddy fields that frame dramatically against the red soil rich in iron oxide.

Apart from its natural beauty, Goa is the heady mix of Portuguese and Indian culture that makes it an attractive destination. Colourful flea markets offer tempting bargains, numerous beach shacks and restaurants offer wide variety of local as well as international cuisine. Today, a wide variety of accommodation is available, from inexpensive guest houses to luxury resorts, making it a natural choice for a value for money vacation. One can come across many westerners who live blissfully in its inviting tropical climate. It is also a convenient launch pad to explore deeper into Northern Karnataka, to discover the treasures of Hampi, Badami, Aihole and Pattadakal, which are all located within a day's drive. Owing to its location on the Western Ghats range, it has rich flora and fauna, and is classified as a biodiversity hotspot. Goa is famed for its sunny beaches and has a coastline of 101 kms (63 miles).

Being located in the tropical zone near the Arabian Sea, it has a comfortable warm and humid climate for most of the year.

Goa is also known for its world heritage architecture that includes Se's Cathedral and the Basilica of Bom Jesus in Old Goa. The Basilica holds the mortal remains of St. Francis Xavier, regarded by many Catholics as the patron saint of Goa (the patron of the Archdiocese of Goa) is actually the Blessed Joseph Vaz. Once every decade, the body is taken down for veneration and for public viewing. On this occasion, Goa becomes one of the biggest Christian pilgrimage sites in Asia.

Goa's history stretches far back into the 3rd century BC, when it formed part of the Mauryan Empire. It was later ruled by the Satavahanas of Kolhapur, who finally gave way to the Chalukyas of Badami, who in turn, ruled it from 580 to 750 AD. Over the next few centuries, the Silharas successively ruled Goa. The Kadambas, a local Hindu dynasty based at Salcete, laid an indelible mark on the course of Goa's pre-colonial history and culture.

Page 194: There are numerous beaches in Goa that are secretly hidden behind mountain cliffs and volcanic rocks; discovering them has its own rewards.
Page 195: A Goan housekeeper looks out at the Arabian Sea through the swaying palms. *Page 196, Top:* Beautiful altar of Se's Cathedral in Goa.
Page 196, Bottom: Entrance façade of Bom Jesus Church which houses the mortal remains of St. Francis Xavier. *Page 197, Top:* A Christian shrine overlooks the sweeping Arabian Sea in Anjuna Village. *Page 197, Bottom:* The façade of St. Francis Church in Old Goa.

In 1312, Goa came under the governance of the Delhi Sultanate. However, the kingdom's grip on the region was weak, and by 1370 they were forced to surrender to the Vijayanagar Empire. The Vijayanagar monarchs held on to the territory until 1469, when the Bahmani sultans of Gulbarga appropriated it. After that dynasty crumbled, the area fell to the hands of the Adil Shahis of Bijapur, who made Velha Goa their auxiliary capital. The first resemblance of a Goan identity began to emerge during this period. "Goa", then was a cluster of huts concentrated around the head of the Zuari River, which prospered as a result of thriving sea trade with the Arabs.

In 1498, Vasco da Gamma became the first European to set foot in India through a sea route, landing in Calicut in Kerala. He later made his way to Old Goa. Goa then was the largest trading centre on India's western coast. The Portuguese arrived with the

intention of setting up warehouses, since the Ottoman Turks had closed traditional land routes of spice trade used by the Arabs to India.

In 1510, Portuguese admiral Alfonso de Albuquerque defeated the ruling Bijapur king with the help of a local ally leading to the establishment of a permanent Portuguese settlement in Velha Goa (or Old Goa) and got a hundred year head start among the European colonizers. The Portuguese intended it to be a colony and a naval base, distinct from the fortified enclaves established elsewhere along India's coasts.

With the imposition of the Inquisition (1560–1812), many of the local residents were forcibly converted to Christianity by missionaries, threatened by punishment or confiscation of land, titles or property. Many converts however, retained their Hindu heritage. With the arrival of the other European powers in India in the 17th century, most Portuguese possessions were surrounded by the British and the Dutch. Goa soon became Portugal's most important colony in India, and was granted the same civic privileges as Lisbon. By the mid 17th century, Goa's decline as a commercial port began to reflect the decline of Portuguese power on the west coast of India. Consequently, it suffered several military losses to the Dutch and the British. Brazil had now supplanted Goa as the economic centre of Portugal's overseas empire.

In 1843, the capital was moved to Panjim from Velha Goa and the area under occupation had expanded to most of Goa's present day state limits.

The British left India in 1947, while the French quit their tiny possession of Pondicherry in 1954. However, the Portuguese, under the dictatorial Salazar refused to leave. Finally in 1961, left with no diplomatic option,

The volcanic rock on the Vagator Beach is carved into a beautiful sculpture by a European artist. **Opposite page, Top:** Women selling handcrafted textiles in the weekly market. **Opposite page, Bottom:** Beaches in Goa are an interesting place to watch people; the eclectic dressing scene throws up some contrasting visuals. People from different parts of the world come to unwind in its relaxed atmosphere, where humans and animals share the beach with equal gaiety.

the Indian army simply moved into Goa, encountering little resistance, liberated it on 17 December. Thus, liberating one of the longest held colonial possessions in the world. Portugal recognised Goa only in 1974 after the Carnation Revolution.

Centuries of Portuguese domination has left an enduring mark on Goa's culture, food and architecture.

In many parts of Goa, mansions constructed in the Indo-Portuguese style architecture still stand in some villages. People from India and abroad are buying and restoring these period homes from their dilapidated condition. Fontainhas in Panjim has been declared a protected heritage quarter, showcasing the architecture of Goa.

Apart from tourism that is Goa's primary industry, mining of minerals and ores forms the second largest industry. The Mormugao harbour on the mouth of the river Zuari is one of the best natural harbours in South Asia.

Above and Opposite page: Anjuna Beach in North Goa was the haunt of the flower children in the seventies. It has managed to conserve its laid-back ambiance as it is not accessible by road. Every Wednesday, the sleepy village comes alive with the weekly colourful market, where the westerners and locals put up the stalls hawking vast array of colourful artifacts. **Page 198–199:** Majority of beaches in Goa are inhabited by local fishing communities. Popular beaches have shacks dishing out local and international fare to vast number of sun worshippers. The coconut-fringed beaches are lapped with warm waters of the sea, making it an idyllic holiday destination.

Above and Opposite page: Centuries of Portuguese domination has left an enduring mark on Goa's culture, food and architecture. In many parts of Goa, mansions constructed in the Indo-Portuguese style architecture still stand in mute testimony of the longest colonial rule ever. Carved wood and Chinese ceramics from Macau are used extensively in the decoration of elite homes.

SOUTH INDIA

SOUTH INDIA

Aurangabad, Ajanta & Ellora

The city of Aurangabad was originally known as Khadki. It was founded by Malik Amber in the year 1610. Later, it was named after Aurangzeb, the sixth Mughal ruler, who made this town a base for his expansion in the Deccan region. Aurangabad is known for its monuments like the Bibi-ka-Maqbara, a poor imitation of the Taj Mahal. Prince Azam Shah built it in 1678, in the memory of his mother, Begum Rabia Daurani, queen of the emperor Aurangzeb. The tomb shows the decline in the Mughal architecture in the span of just 25 years as compared to the Taj Mahal in Agra.

The invincible Daulatabad Fort and Aurangzeb's burial spot at Khuldabad are not far away. As places of interest, these are overshadowed by the Ajanta and Ellora Caves nearby, which are now declared as World Heritage Monuments.

Ajanta Caves are situated in a horse-shoe shaped valley of the river Wagdogra, 65 miles (105 kms) northeast from Aurangabad. Its serene surroundings and the proximity to the trade routes made it the centre of Buddhist art and philosophy from the second century B.C. till the sixth century A.D. There are around thirty caves on the Deccan plateau that were excavated in two distinct phases. The earlier Hinayana phase in which Buddha was worshipped only through symbols such as Bodhi tree, footprints and stupas.

In the later Mahayana period, Buddha was worshipped in human form. The caves of the Mahayana period introduced Buddha idols in place of stupas of the Hinayana period.

The Ajanta Caves were lost to the civilization for over a thousand years. A British soldier, John Smith, accidentally discovered them in 1820, while he was in pursuit of a tiger. Being lost to the civilization for centuries proved a boon in disguise for these temples and monasteries as they escaped defacement from marauding invaders.

The caves at Ajanta show the transition of the temple architecture from wood to that of stone. In many roofs, the imitation of wooden beams is apparent (Cave no. 19). The temples were carved out of cliff face from front to the back, then from top to bottom. The caves are divided into Chaityas, the prayer halls and Viharas, the monasteries. Tempera paintings that decorate the walls and ceilings of some caves are narrative in

Above: Panoramic view of the Ajanta Caves, which were built during 2nd century BC till 5th century AD. **Opposite page, Left:** Marble screen in Bibi-ka-Maqbara. **Opposite page, Right:** Sculpture of the door keeper in Ajanta Caves.

SOUTH INDIA

SOUTH INDIA 209

Cave No. 17 at Ajanta shows the climax of fresco piantings during the Mahayana phase (between the 4th & 5th century AD). Here, the story of Simhalavadana is depicted with great sensitivity. ***Opposite page:*** Spectacular fresco of Bodhisattva Padmapani or the lotus bearer in the Cave No. 1 of Ajanta. ***Page 206:*** Cave number 16 also known as the Kailasha Temple as seen from the south-west corner of the hill which was excavated to make this giant monolithic marvel. ***Page 207:*** Bibi-ka-Maqbara was made by Aurangzeb in memory of his mother, copying the world famous Taj Mahal.

Kailasanatha Temple of Ellora is truly a remarkable feat in architecture. Entire mountain was chiseled from top to bottom and from front to back to leave a monolithic temple structure in the middle. What is even more noteworthy is that it was built in the ninth century AD.

nature and richly depict the daily life as well as the epic stories of Buddhism. Although only four colours namely red, blue, yellow ochre and lampblack were used, the paintings emerge as vivid and expressive along with strong composition.

The rough walls of the caves were covered with an inch thick plaster made out of clay and cow dung and portions of rice husk were added. Once the plaster dried, a layer of lime plaster was applied. The outlines of the paintings were done in red on wet plaster. The colours used were locally procured except the blue, which was imported; hence it has been used in small quantities. Pools of water were made in order to reflect the sunlight in the darkest corners of the caves for the artists to work.

The earlier Hinayana paintings are simple by nature and mostly two-dimensional. The later Mahayana paintings are highly stylized where the artist have used the depth in the perspective and covered the entire walls with the Jatakas, the stories related to the earlier incarnation of Buddha as Bodhisattva. These are beautifully illustrated in vivid colours and life-like vibrancy. These paintings depict colourful Buddhist legends of divinities, with an exuberance and vitality that is unsurpassed in Indian art. Noteworthy being the painting of the Bodhisattva Padamapani, the lotus bearer in Cave number one. The sensual and spiritual blend in painting art is beautifully accomplished in the cave temples of Ajanta more than fifteen hundred years ago.

About thirty kilometers from Aurangabad, close to the fort of Daulatabad, lie the Ellora Caves. In all, thirty-four cave temples were excavated between the fifth and eleventh centuries. Unlike Ajanta, which is purely Buddhist, the Ellora Caves are a mixture of Buddhist,

Page: 212–213: Cave No. 26 in Ajanta is the chaitya-griha or the worshipping hall, ornamentation of which is executed in meticulous details. Showing the phase of Mahayana, the stupa is pushed into the background and Buddha's figure in the preaching mode is more prominent. The ribbed beams supporting the vaulted roof are imitation of the original wooden structures.

Hindu and Jain religions. The Buddhist caves are the oldest and pertain to Mahayana sect who started the idol worship. In contrast to the Ajanta Caves, the existence of Ellora was known to the local population. Being situated on ancient trade route, it has been referred as Verul in accounts of the Arab traders. It is estimated that for the construction of these temples some 200,000 tons of rock was excavated. Out of the thirty-four caves, twelve belong to Mahayana Buddhism, and date from fifth to the seventh century. These are located towards the south. Seventeen Hindu caves date from eighth to the ninth century lie in the centre. In the north are the remaining five Jain caves, which were constructed between the ninth to the eleventh century.

Out of the numerous Viharas or the monasteries made in the Buddhist group, "Teen Tal" or the three storeys one is most amazing. Compared to the Hindu caves, the Buddhist caves are quite simple. Hindu caves are adorned with the dynamic statues of the various gods and goddesses, representative of the dynamic energy. The zenith of temple architecture at Ellora is Cave number 16, the Kailasha Temple, named after the lofty Himalayan mountain abode of Lord Shiva. Unlike other caves, which were excavated inside the mountain from the front to the back, in Kailasha, an entire mountain was chiselled to leave a giant temple, probably the biggest monolithic temple in the world, carved out of an entire mountain.

Construction of the Kailasha Temple began in the eighth century, beginning in the reign of Krishna I, (Krishna I; 756 - 773) of the Rashtrakuta dynasty. It took about ninety-three years to be completed. It involved the removal of three million cubic feet of solid rock to form a temple that is 276 feet long, 154 feet wide, and 107 feet deep, with four levels, or storeys. Despite of its giant size, it is elaborately carved.

Just at the entrance, in the porch is the beautiful carving of Laxmi, Hindu goddess of prosperity, seated

Above, Top: The entrance of Kailasha Temple at Ellora is decorated with a statue of Laxmi flanked by elephants who are pouring water on her with their trunks. **Above, Bottom:** Four lions guarding the roof of Kailasha Temple. **Opposite page:** Cave no. 30 is also known as Chotta Kailasha is dedicated to Jain religion. These caves date back to the 9th century and show the last phase of development in the rock-cut temples.

Exquisitely carved façade of Cave No. 10 also known as Vishwakarma at Ellora. **Opposite page:** Interiors of the upper storey hall of the Jainist Cave No. 30.

218 SOUTH INDIA

on the floating lotus. The base of the main shrine is twenty-five feet high and is supported by life-size carvings of elephants from the outside. The best of friezes is of the ten-headed demon king, Ravana shaking Kailasha. It narrates the incident from the Hindu epic Ramayana, when the demon king Ravana, intoxicated with his strength, shakes Mount Kailasha, where Shiva is residing with his consort Parvati. Although Parvati looks alarmed by the incident, Shiva on the other hand suppresses the giant with a gentle tap of his foot.

Another carving which reflects the dynamic energy of these sculptures is that of Vishnu in Narasimha, half-man-half-lion avatar, killing the demon Hiranyakasipu. The narration of Ramayana in a frieze is another remarkable panel.

The glory of the temple is aptly described in the words of Percy Brown, an authority on Indian architecture, "Kailasha Temple is an illustration of one of those rare moments when men's mind and heart work in unison towards the consummation of a supreme ideal".

Mumbai

Bombay is the commercial capital of India. The city which is less than 500 years old since its 'discovery' by the Portuguese has metamorphosed into a sprawling megalopolis of thirteen million people. Bombay is India's most dynamic and westernized city. It does not have a distinct regional character because of its mixed population. The separate identity each community maintains has given rise to a mix of places of worship, customs and rituals, making it very cosmopolitan.

In 1996, Bombay was renamed Mumbai, which is the Marathi name of a local deity. It is also the film capital of India with the largest film industry in the world.

Mumbai originally consisted of seven islands inhabited by small Koli fishing communities. The Portuguese handed the largest island of Bom Bain (Good Bay) to the English in 1661, as part of Catherine of Braganza's dowry when she married Charles II. A few years later in 1668, it was leased to the East India Company for a pittance. The city grew in importance with the opening of the railways in the nineteenth century, and its natural harbour became an international port of call with the construction of the Suez Canal in 1869. The Civil War in America caused the cotton supplies to shrink in the world market. This proved to be the boon in disguise for the city. Millions were made as the city was located close to the cotton-producing region and had a natural port to boast of. The Gothic buildings which dominate the Bombay's skyline date from this period.

Subsequently, Mumbai rapidly became the centre of an entrepreneurial as well as a commercial class, drawing from the Parsis as well as Bania and Gujarati business community. The small Parsi community has been instrumental in the development of the Indian industry with the result that Tatas are a household name in India. The family gave Bombay its landmark, the Taj Mahal hotel. Built in Edwardian style by Chambers in 1903, it is still regarded as one of the finest hotels of the world.

Victoria Terminus Railway Station was named in honour of the Queen and Empress Victoria; it was opened on the date of her Golden Jubilee in 1887. Architect Frederick William Stevens built this famous architectural landmark in Gothic style, in 1887-1888. Every day some six million commuters come in from suburbs in these local trains. **Opposite page:** Sexologist offers his services on the sidewalks of the city. **Pages 222–223:** The view of the Marine Drive also known as the Queen's Necklace as seen from the Kohinoor Suite of The Oberoi, Mumbai.

तस कमजोरी (SEX WEAKNESS)

ANY SEX PROBLEM
FREE ADVISER
(ONLY MONDAY) MOBILE-9869371093

Above: Gateway of India as seen from the suite of the Taj Mahal hotel at dawn. **Page 220:** The Taj Mahal hotel was built by Jamsedji Tata in 1903 after he was refused entry to Watson's Hotel, as it was restricted to 'whites only'. The project was completed by an English engineer W. A. Chambers. During World War I, the hotel was converted into a 600-bed hospital. The dome of the hotel is made from the same steel as used in the Eiffel Tower.

Besides the Maharashtrian, Gujarati and Christian communities, there is also a small minority of Jews and Parsis. The influence of the various cultures existing simultaneously is evident in the architecture of the city. Unlike Delhi, which is sprinkled with ruins of the Muslim dynasties, it is the British landmarks that stand out in Bombay. Prime among them is the Gateway of India. It was designed by George Wittet to commemorate the visit of King George V and Queen Mary in 1911. Ironically, it was through this very arch that the last contingent of British troops (1st Battalion Somerset Light Infantry) in India left by sea in 1948. Wittet also built the Prince of Wales Museum.

The Victoria Terminus, also popularly known as VT was built in the last quarter of the nineteenth century by F.W. Stevens. It is a truly remarkable Victorian Gothic style building. The numerous sculptures decorating its façade were designed by Thomas Earp and executed by the students of the Arts College.

A visit to the Victoria Terminus will give a taste of the pulsating energy of the city. Other colonial buildings include Old Secretariat, Crawford Market, and the Municipal building.

More than the architecture, it is the sea which surrounds the city on three sides that dominates the cultural consciousness of the city and dictates its lifestyles. Beaches and seaside promenades like Marine Drive, Chowpatti and Juhu beach, and the outlying resorts of Madh Island, Marve, Manori and Gorai, though eaten into by the spread of urban expansion, are still a visitor's delight.

Mumbai is also the departure point for the Elephanta Caves. This enchanting island, an hour away by motor launch, offers a welcome getaway from the chaos of the city. There are a series of beautiful rock cut caves

Page 221: Gateway of India is built from yellow basalt and reinforced concrete in Indo-Saracenic style architecture. It was built to commemorate the visit of King George V and Queen Mary to Bombay, in December 1911. The last British troops to leave India, the First Battalion of the Somerset Light Infantry, passed through the Gateway in a ceremony on 28 February 1948.

SOUTH INDIA

Above, Top: Prince of Wales Museum. **Above, Bottom and Opposite page:** The beauty of Victoria Terminus Railway Station comes alive with the setting sun.

SOUTH INDIA

with temples and sculptures dating back to the sixth century. The island was named by the Portuguese, in honour of the carved elephant they found at the port. Its chief attraction is the unique cave temple, which houses a six-meter high bust of Shiva in his three manifestations as Creator, Preserver and Destroyer.

Mumbai is the most prosperous city in the country, with a cost of living almost equal to that in the US, and houses some of the most expensive properties in the world. However, poverty continues to be a growing vice with one-third of Mumbai's population living in slums or shantytowns. Despite communal tensions and a growing mafia nexus posing a grave threat to the city, Mumbai maintains its status as the financial, commercial and entertainment capital of India.

Above, Left: View of the interior patio of Taj Mahal hotel, Mumbai. **Above, Right:** The Venetian Gothic Bombay University has a Gothic clock tower 260 feet high, that is curiously adorned with oriental figures. In the old days, it used to play 16 tunes that changed four times a day. **Opposite page:** Dhobi Ghat is also known as the world's largest outdoor laundry. It's a fascinating spectacle, of open-air concrete wash pens, each fitted with its own flogging stone. Here Mumbai's dhobis clean soiled garments in a timeless tradition, by pounding them on stone with great vigour.

The seventh century giant bust of 'Trimurti' representing Brahma, Vishnu and Mahesh (creator, preserver and destroyer) in Elephanta Caves near Mumbai.

(கூரத்தாழ்வான்) (ஸ்ரீ உடை

கோயில் அண்ணன்